# The Iowa State Fair

## Iowa and the Midwest Experience

SERIES EDITOR

William B. Friedricks,
Iowa History Center
at Simpson College

*The University of Iowa Press gratefully acknowledges Humanities Iowa for its generous support of the Iowa and the Midwest Experience series.*

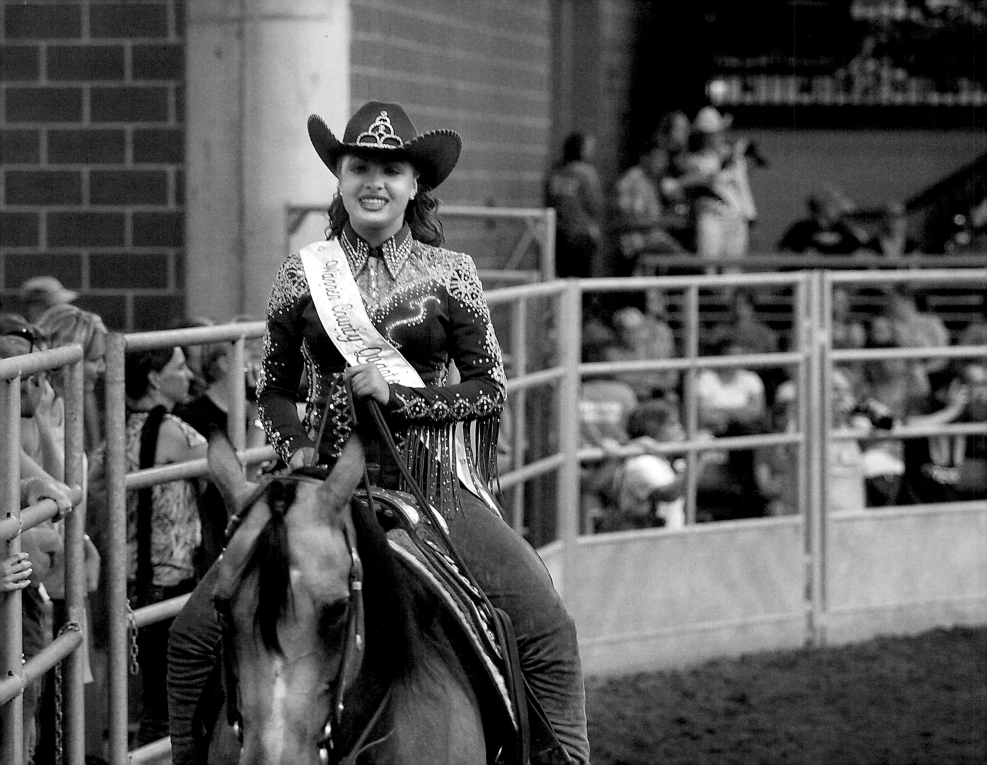

# The IOWA STATE FAIR

★★★★★★★★★★★★★★★★★★★★★★★

*Photographs and Text by* **KURT ULLRICH**

**University of Iowa Press, Iowa City**

University of Iowa Press, Iowa City 52242
Copyright © 2014 by the University of Iowa Press
www.uiowapress.org
Printed in the United States of America

Design by Kristina Kachele Design, llc

The University of Iowa Press is a member of Green Press Initiative
and is committed to preserving natural resources.

Printed on acid-free paper

ISBN: 978-1-60938-278-0 (pbk)
ISBN: 978-1-60938-302-2 (ebk)
LCCN: 2014932407

**For Bobbi and Mardie**

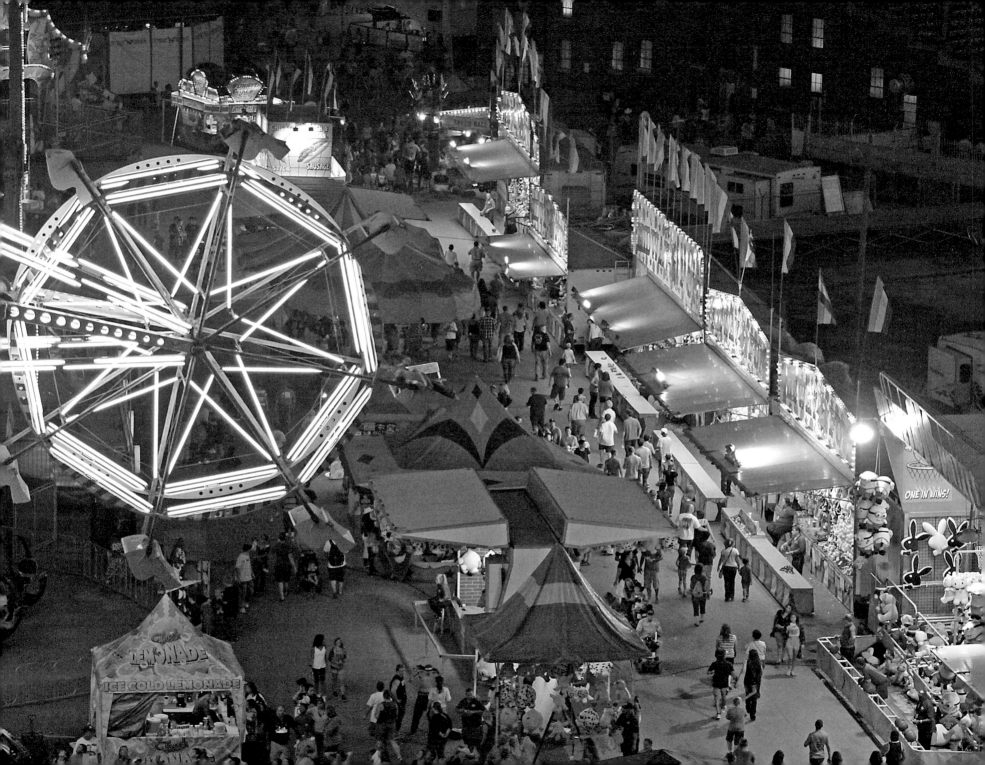

# CONTENTS

## Acknowledgments

My time at the Iowa State Fair has always been intensely joyful and for that I can heartily and lustily thank all of those who gave of their time; chatting, telling their stories, and confiding in a man they'd never seen before and would likely never see again. And to those who allowed me to point a camera in their direction? Well, what can I say? I appreciate it and I owe you.

I would be remiss in not also thanking the good people at the University of Iowa Press, particularly Catherine Cocks and Allison Means, friends and scholars who have been unfailingly supportive, helpful, and accepting. For that, I will always be grateful.

Paul Yeager of Iowa Public Television, likely one of the best television producers in the business, has been extremely supportive, and not just on this project, but on other wacky ideas I've entertained in photography, the written word, and music. Thanks, Paul.

Another big thanks goes to those people working the Midway: Amber Swedgan, Dave Kitt, and the hard-working employees of Belle City Amusements, all of whom were unfailingly accommodating.

This project would not have been possible without the support of the brilliant and beautiful Bobbi Alpers, who is the truest friend, most trusted companion, and zaniest assistant one could ever hope to find.

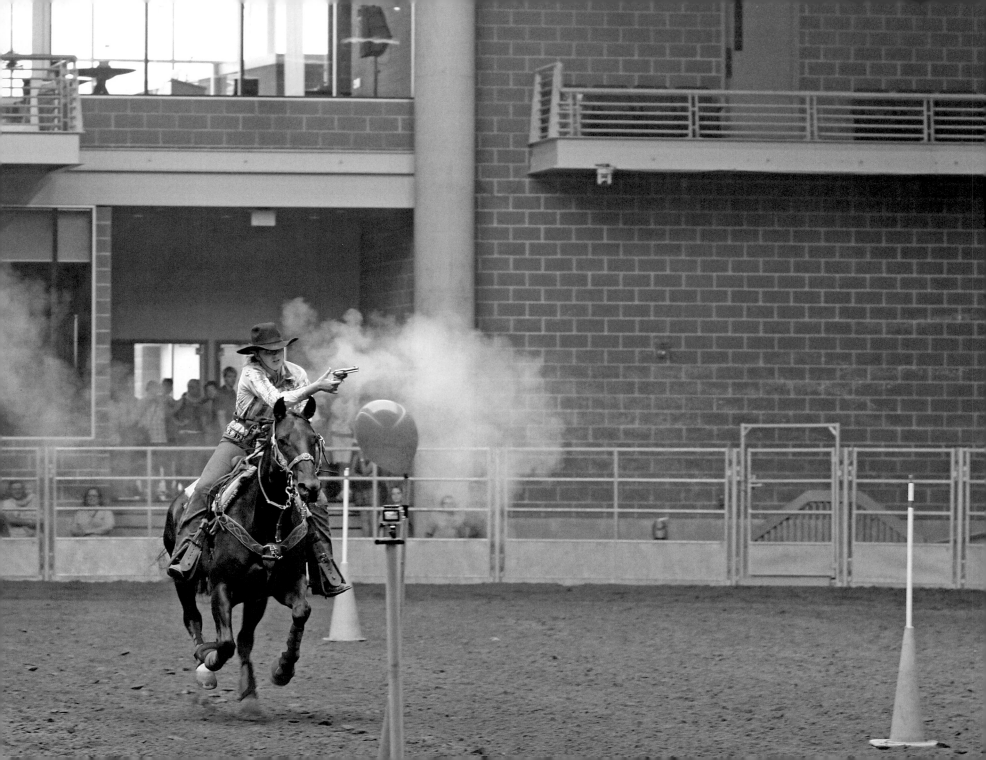

# INTRODUCTION

It's getting late. Up by Pioneer Hall the doors are locked and the windows are open, pulling in the cool night breeze before the next day's events; perhaps a longest beard contest, or a fiddling competition, some remnant of the nineteenth century we embrace because . . . well, just because. Here at the state fair, on any given day, one century easily melts into the next, which is as it should be when celebrating the Americana blend of agriculture, youth, and all things Iowa.

August days are strewn behind us and down by the sheep barn, Summer can be seen glancing at her watch. She knows that soon enough it will be September, school will be in session again, and the days will, as the Kurt Weill song says, "dwindle down to a precious few." They always do. So come join me: We'll walk arm in arm through the barns where cattle are lowing, where sheep look up as we pass, passing through a peaceable kingdom from a painting by Edward Hicks.

At dusk we'll stroll slowly along the fluorescent and neon avenue they call Rock Island, no longer glowing in the yellow light of hissing gas lamps and candles as in years past. Overhead, a summer yellow-jacket moon reminds us

1

of where we are. It's a middle-of-Iowa pedestrian cauldron of human energy, a place with few demands, and more than enough stuff-on-a-stick. Take a seat, grab a beverage, and sooner or later, like in Grand Central Station in New York City, you'll see someone you know. Guaranteed.

Later, you and I will go north, toward the Midway and the Grandstand where, on certain nights, tractor stacks belch black smoke into a molten sky and, on other nights, country singers take a G-chord route to heartache and lost love.

We'll smile, pretend we're a lot younger, stop for a lemonade or something stronger, and talk briefly about those who have gone before, those we miss when things get quiet, saying things like, "Yeah, dad would have loved the grocery-bagging competition."

Soon we cross the Grand Avenue Concourse into a world that only comes around once a year, a dark carnival of loud techno-pop music, the wheezing whoosh of hydraulic rides, and the voices, always the voices.

And I'll laugh, perhaps a little nervously, when a carnival barker looks at me, points, and speaks before I do. "You there, with the beautiful lady. Step right up." I don't, but a small part of me regrets the decision. And, of course, he's right. She's beautiful.

When given the opportunity, we choose to do those things that give us pleasure. Perhaps it's driving across a rural landscape on a warm day, windows down, dust rising in our wake, radio up full volume. Or it's sitting with a loved one on a front step, talking quietly of nothing in particular, nodding as a neighbor passes. For many of us, pleasure and delight comprise this great, mid-summer sonata played on a grand scale in the center of Iowa at a place called the Iowa State Fair, a place where sheep bleat in unison, cattle low in solo, and the rest of us sing in full-throated, unmitigated joy.

# HISTORY

"Are there people buried under here?" a small, concerned child asks her mother. Closer to her eyes than to ours, memorial bricks have been carefully laid in a number of places around the grounds, here in front of the aptly named Cattle Barn, bricks with family names, some current, but most relegated to a singular family history.

History is memory and memory is selective, but here at the fair the memories are clear, precise, often involving someone long gone from this earth. "I think the last time I was here I was a kid, with grandpa and grandma," a middle-aged woman tells her elderly parents as they take a momentary break on a bench along the Grand Avenue Concourse, a bench with a small tag bearing a family name, indicating the bench was a gift made to keep others' memories alive. History circles these grounds constantly, not in an academic sense, but in the way that one thing follows another, no longer in the present.

On the edge of the campgrounds, old friends sit outside motorhomes, enjoying a beverage at the end of a long day. They've had the same spot near an entrance gate for almost forty years and they don't really need the services of the tractor-pulled surreys carrying passengers in and out of the fairgrounds,

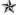

something begun more than a half century ago by a Lions Club in faraway Clearfield.

Ninety years ago, a newlywed couple from far eastern Iowa decided to spend their honeymoon at the fair, driving unpaved roads in a Ford Model T to the campgrounds, where they pitched a tent for a few days before returning to their farm. While one might argue that today's tendency toward living out of a motorhome doesn't exactly constitute camping, later newlyweds opted for more comfort, and by the 1970s many were making the trip to the fair in a motorhome. Stories like this abound in Iowa.

For more than a century, the utterly charming and oddly incomprehensible butter cow has been sculpted and displayed before long lines of fairgoers. These days, many don't see the cow directly, choosing instead to view it through a phone, camera, or small computer, carrying their digital history with them as they depart, willing to show the digitally captured cow to anyone who asks.

More than two centuries ago, a gentleman in Massachusetts named Elkanah Watson put together the first agricultural fair in America, well aware of the fact that European farming practices were far superior to those in the new states. Watson wished to improve breeding and cultivation practices among American farmers and even went so far as to introduce Merino sheep from Portugal to New England. Within a few years, Watson's fair included baking and sewing competitions for the women and a few games and rides for the children. After his first fair, which was pretty much a men-only affair, he realized success could come only if the entire family were involved.

Watson's ghost would feel right at home at today's Iowa State Fair. He would be satisfied visiting the Avenue of Breeds, and he would heartily approve of a man from Atlantic—in the guise of a future president named Lincoln—who shows up on the grounds to say to fairgoers that "government of the people, by the people, for the people, shall not perish from this earth."

Every day, more or less, members of the fair board gather to officially open the fair, bestow awards, etc. After a while you wait for them to break into song, belting out "Good Night Ladies" or "Lyda Rose."

Back to the original question, though, the seemingly easy one posited by a child, a child probably living in a world where no one has yet died: "Are there people buried under here?" The answer isn't as clear as we once thought, so we mumble "yeah, sort of," hoping there are no follow-up questions before we quickly step toward our own history, our own Valhalla, a wide-open, welcoming, barn door.

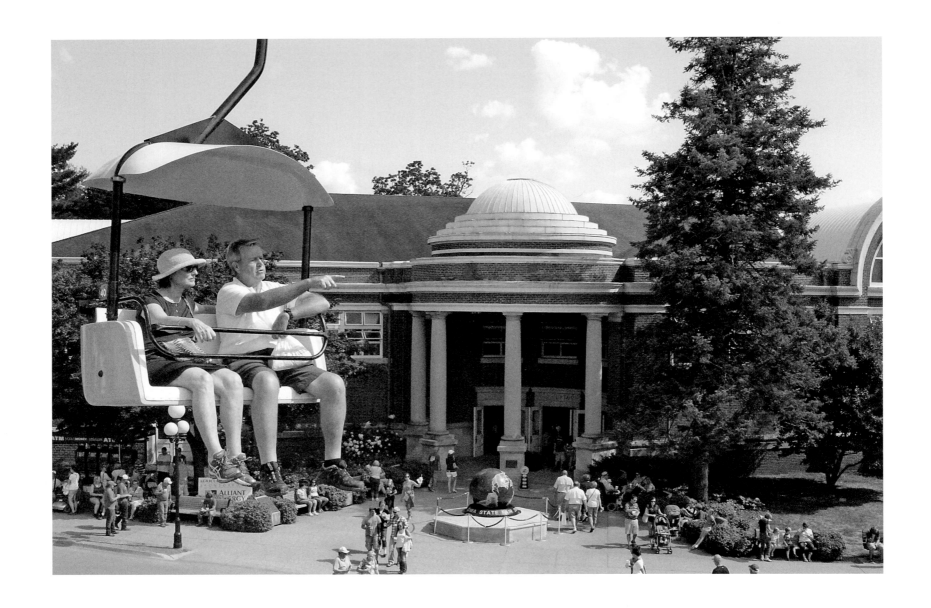

John Deere Agriculture Building

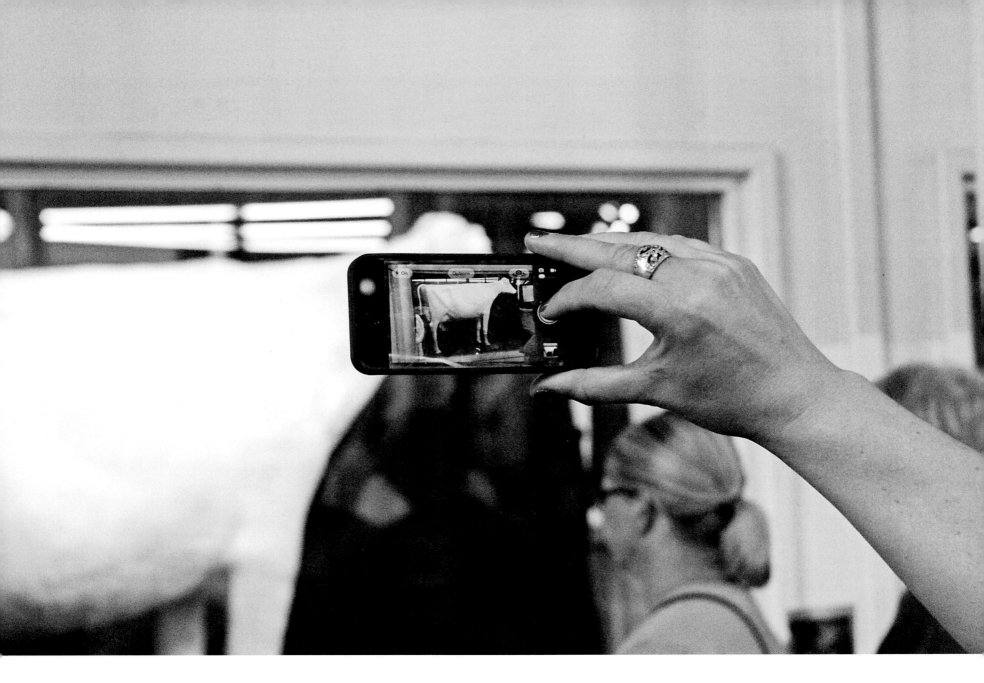

Digital Butter Cow

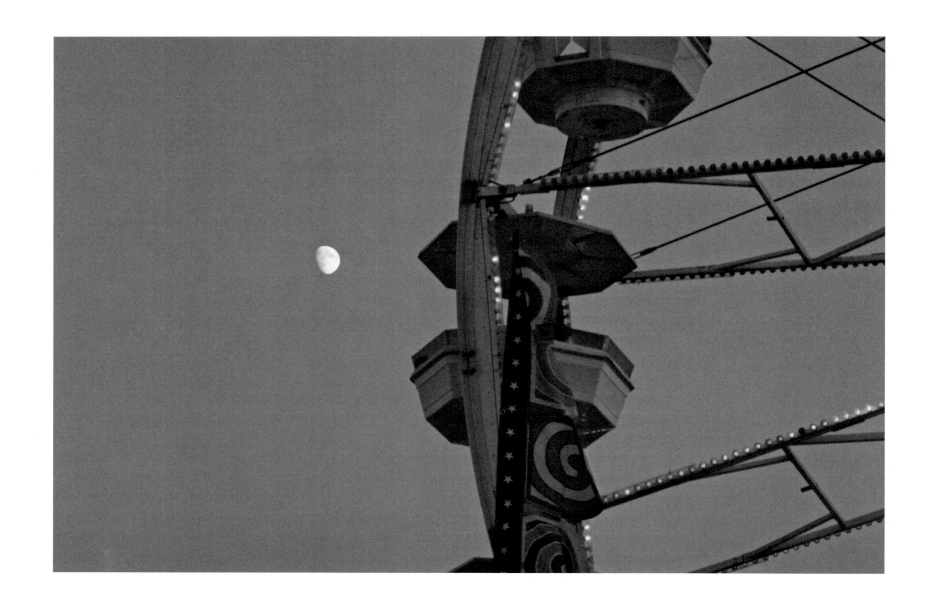

Clear August moon

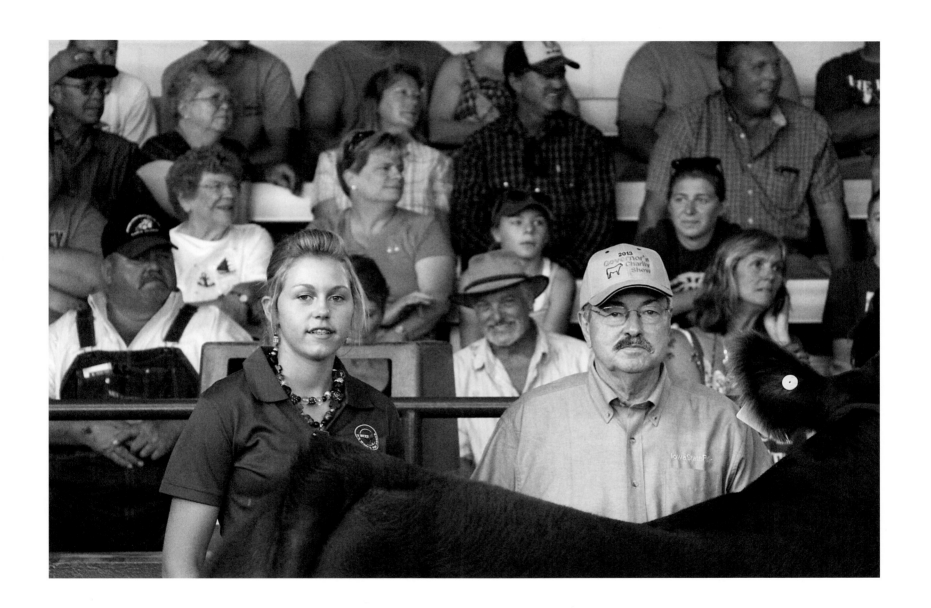

Governor's Charity Steer

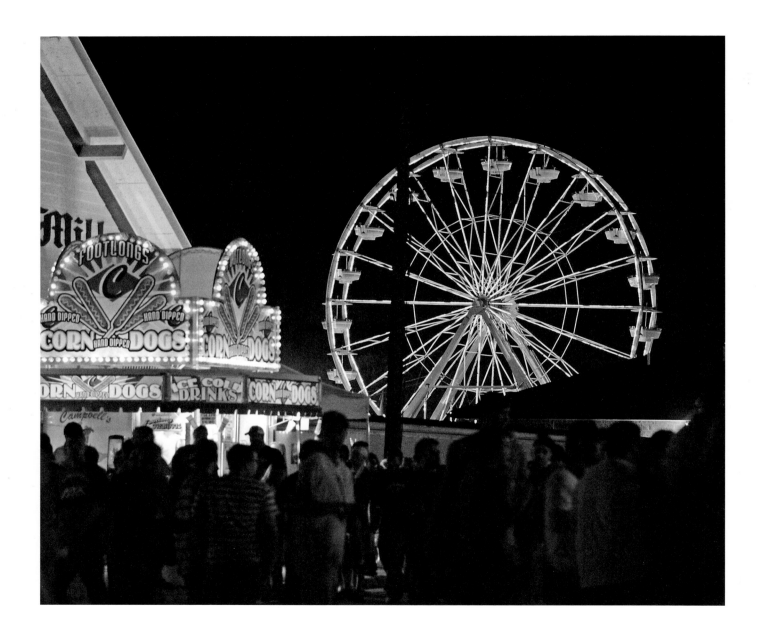

Midway lights

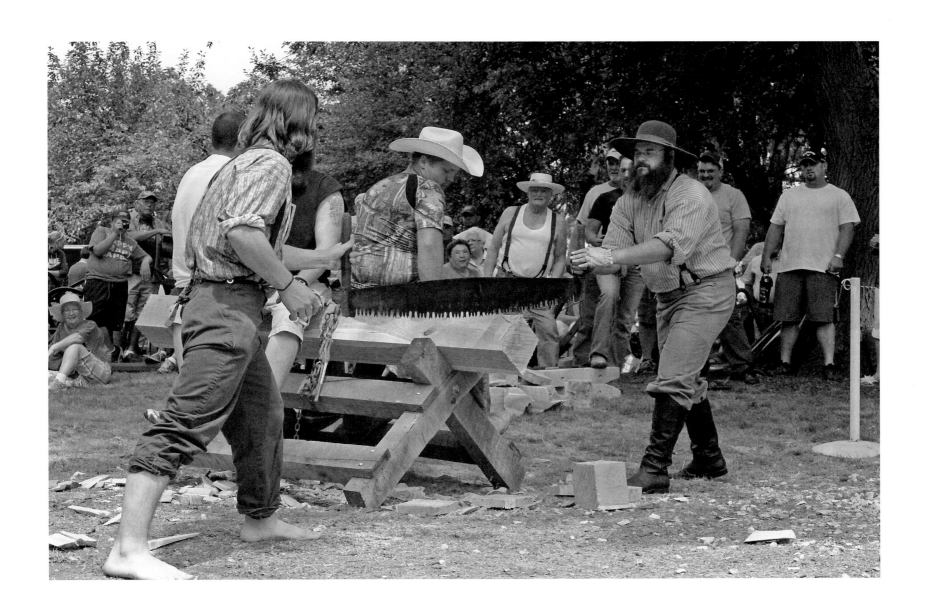

Wood Sawing Competition

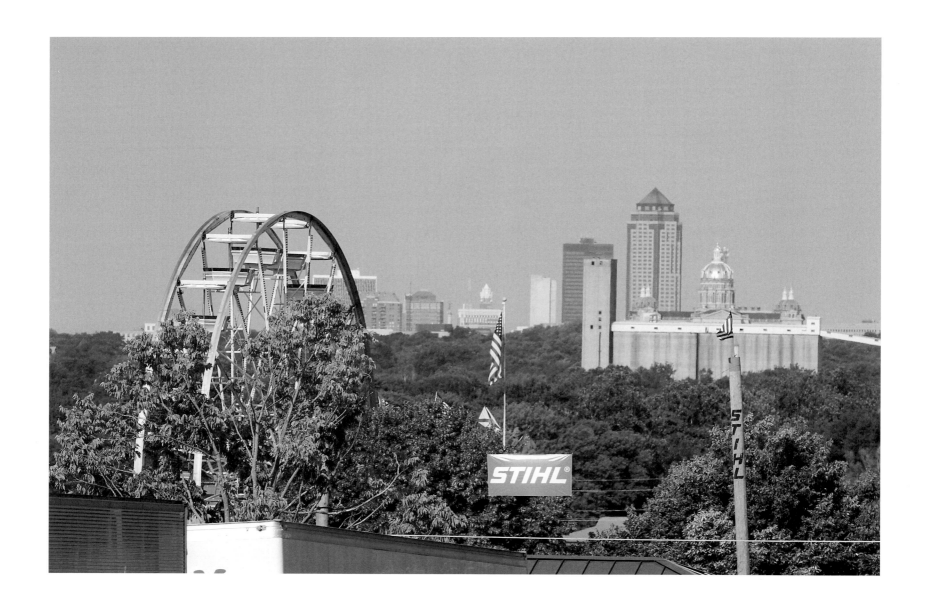

View of downtown Des Moines

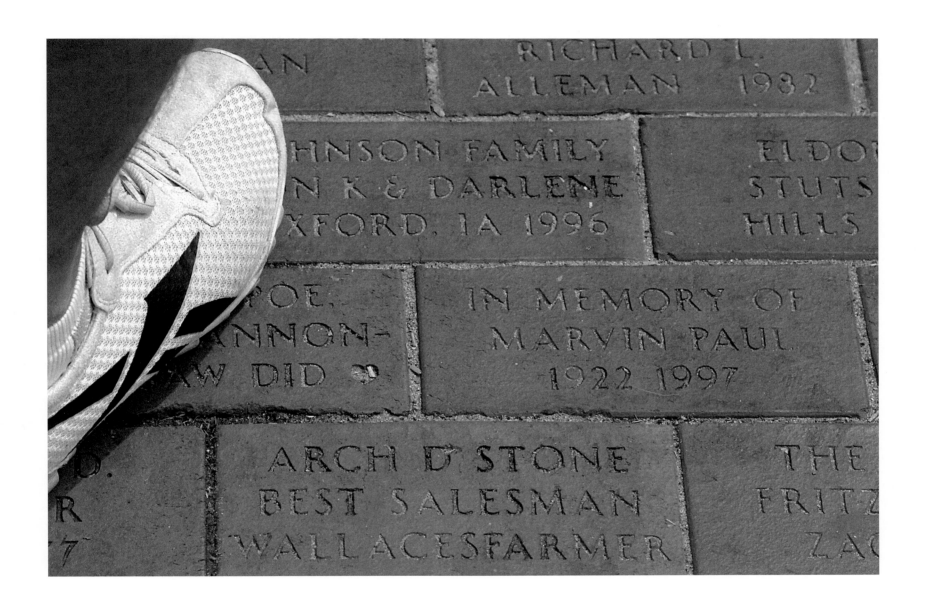

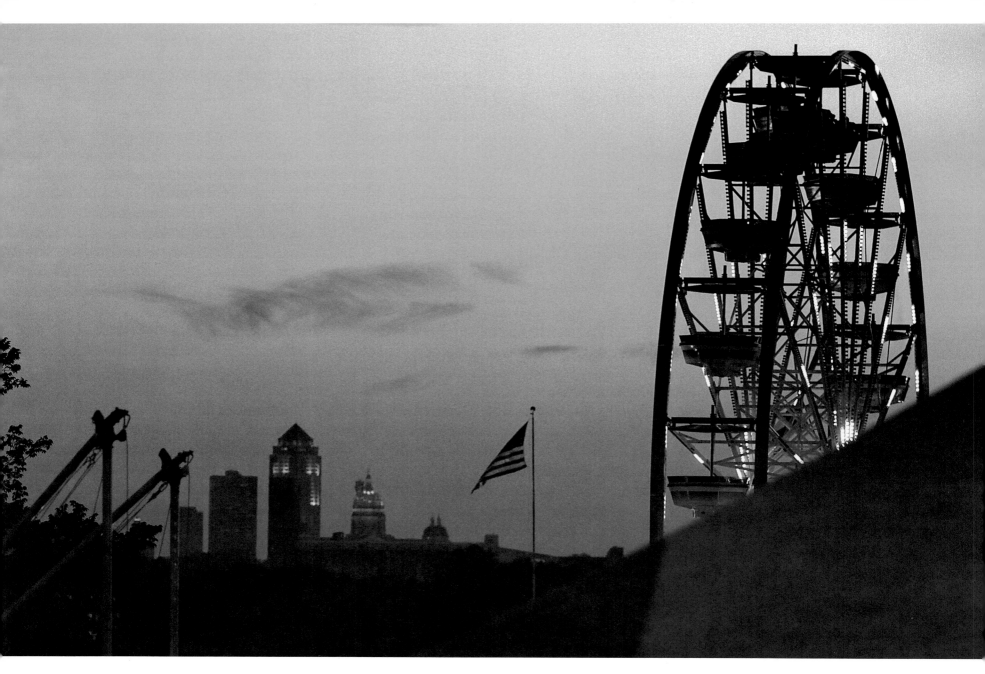

Giant Wheel at dusk

Father and daughter on Giant Wheel

Clearfield Lion awaits passengers

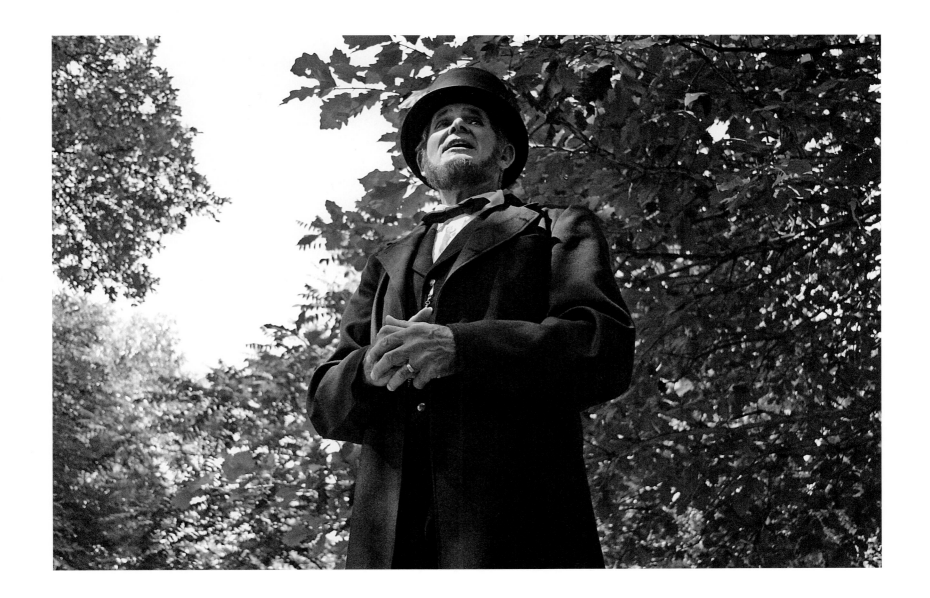

Reenactor delivers Gettysburg Address

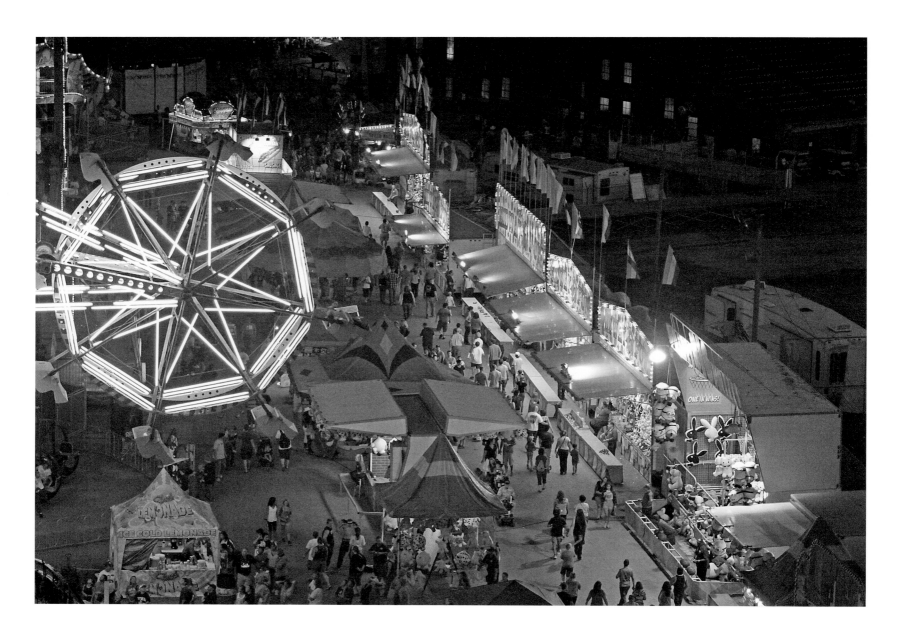

Midway from on high

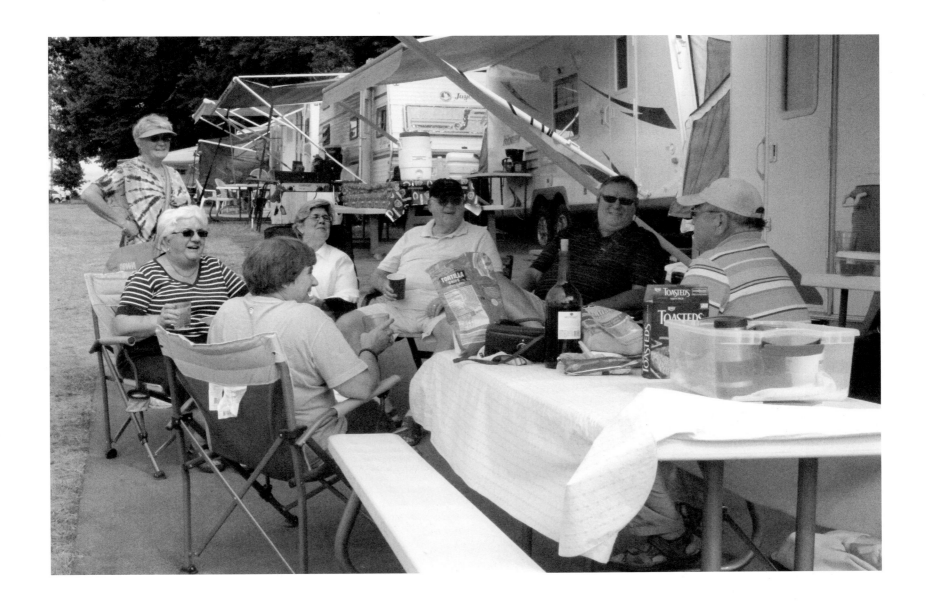

Campers take a snack break

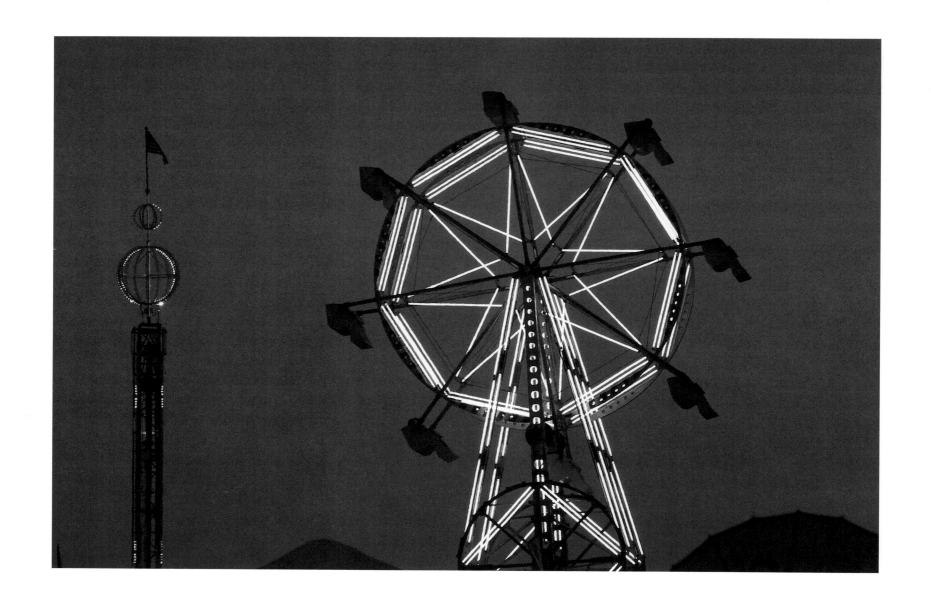

Double Ferris Wheel at night

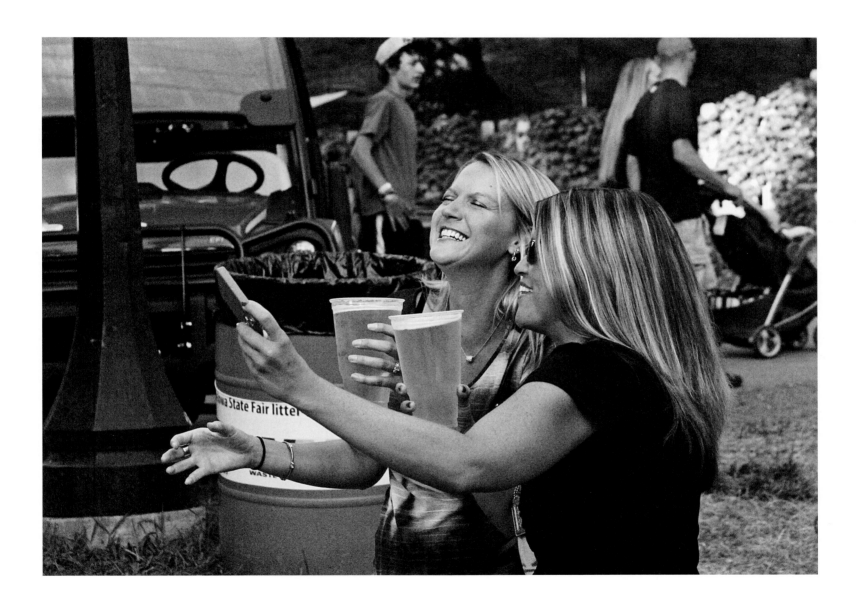

Smiling women take selfies

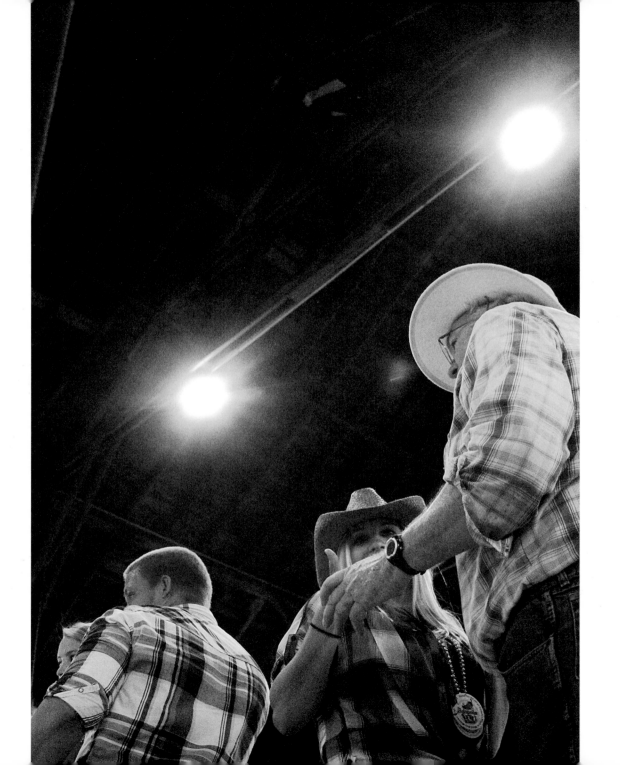

Plaid dancers take a turn

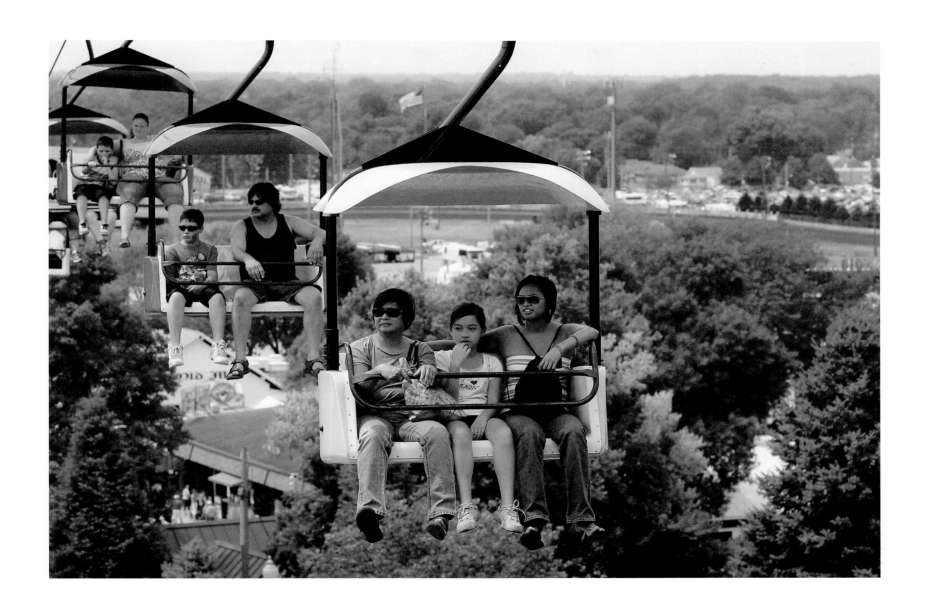

Sky Glider, a fair tradition

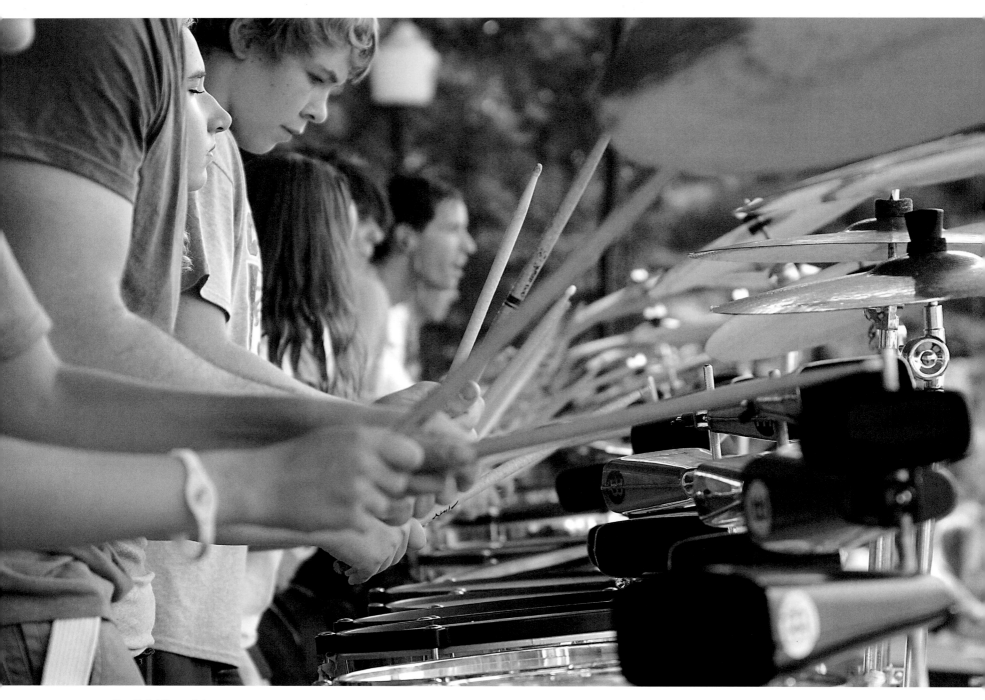

Youthful line of drummers

## SOUNDS

It is seldom quiet at the Iowa State Fair. Every minute of every day the air reverberates with the twenty-first-century sounds of internal combustion engines, industrial fans, electric generators, and hydraulic machines. For a week and a half every summer, a powerful locomotive of human industry crescendos onto the gently sloping hill of a pastoral Iowa garden in Des Moines, a hum of raw power come to life.

You first notice it out on the street, on University Avenue where police officers do their best to direct the hissing automobile traffic toward parking spots. Engines slowing and starting again, music from FM radio stations drifting from open windows in the August heat, a bit of Stevie Wonder singing "Living for the City" or the music of Sly and the Family Stone nostalgically recalling "them summer days" and "hot fun in the summertime."

After a while you don't hear it. All you hear is a general cacophony that sinks to a murmur, rather like that in any big city, particularly at night. You learn to tune in to the person walking next to you, the older woman telling you about her first trip to the fair many years ago, when she saw Andy Williams perform in front of the grandstand. And that very afternoon, in the Varied Industries

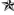

Building, you chat it up with a guy from Wall Lake and "Moon River" runs through your head the rest of the day.

In a small, log church at the base of a hill leading up to Pioneer Hall people are singing. Old men on motorized scooters sit outside the open windows, hymnals in hand, adding their voices to those inside the church singing "How Great Thou Art" and "Battle Hymn of the Republic." These are your people—your grandfather yesterday, you tomorrow.

In the middle of a warm August day, Rock Island Avenue becomes the strolling capital of the world, a Champs-Élysées or Fifth Avenue of un-wrought fashion and eager voices, always voices. Voices belonging to people who understand that wandering the loud grounds of a place with 100,000 of your best friends can be oddly restful. No one yells. Almost everyone laughs.

Over at the Jacobson Exhibition Center one can hear the sounds of gunshots as members of the Mounted Shooters of America ride horses at breakneck speed, firing six-shooters at red and white balloons. Under any other circumstances the crack of gunfire would be troubling. Here, it fits nicely with the sounds of talented fiddlers at Pioneer Hall up the road, strings resonating on their violins in the warm afternoons.

Back out on the grounds, in the deep shade of an oak near the Anne and Bill Riley Stage, you hear the lush, memory-inducing sounds of a marimba. Perhaps vibraphonist Red Norvo has come back to life, or jazz artist Gary Burton, two mallets in each hand, stopping by for a brief set. Instead, it's a high school sophomore from western Iowa, rehearsing before taking the stage in a talent contest, and all you can do is smile, thank him for the sweet interlude, and wish him well.

As dusk begins to settle somewhere over Nebraska, the sounds change. Welcome to the new world, where the music of a guy named Antonín Dvořák, who spent a summer in Spillville long ago, gives way to the insistent sounds of rock

and roll and country music. A heavy metal band stalks the Budweiser "Bud" Stage while a country band gears up at the Susan Knapp Amphitheater. There is something for everyone.

Over on the Fairview Stage, Iowan Bob Dorr leads his band through the sounds of Memphis and other places further down a muddy river, blues from a silted delta, north to the south side of Chicago, and suddenly the night feels deeper than it's felt all year.

Long before midnight, the sounds have settled back to a constant overtone of electronic machinery, the rides on the Midway, amplifiers on stages, and whirling fans in the barns. It's a reminder that the sounds of the tree frogs and coyotes back home would be hopelessly covered up here, that the best sound is still the human voice, the real sound of summer, the sweet sounds you hear when the person walking beside you in the half-light of an old barn speaks.

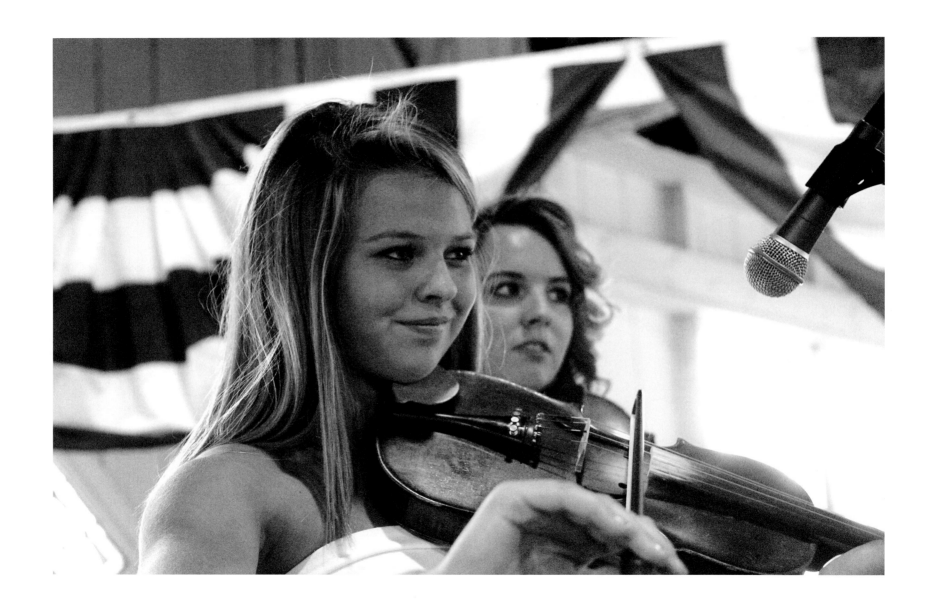

Best young fiddler at the fair

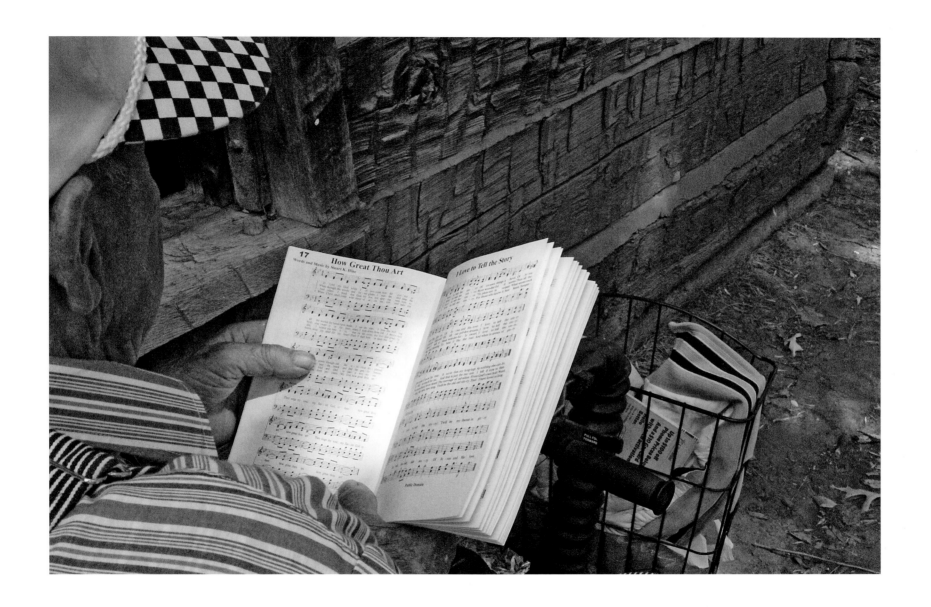

First Church Hymn Sing

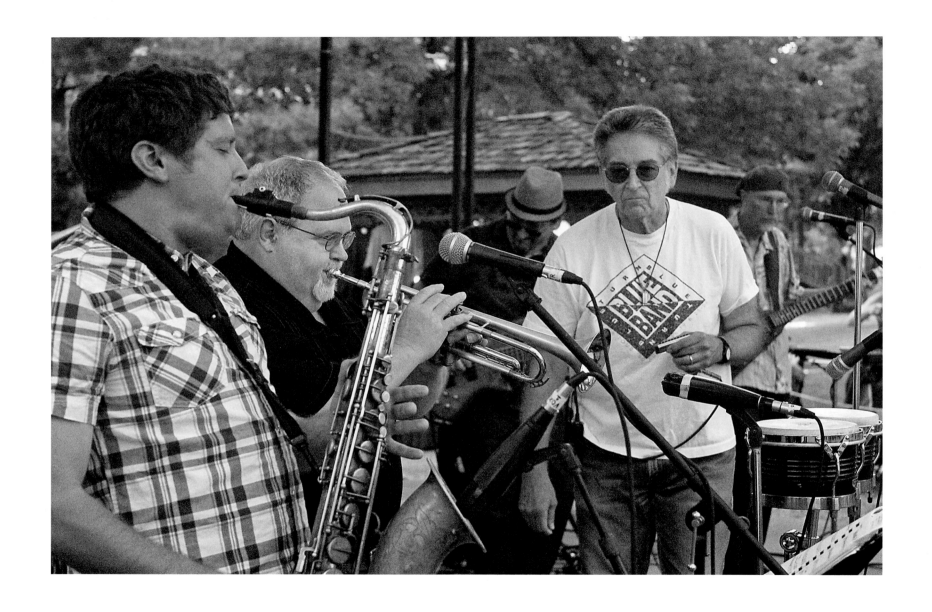

Bob Dorr & the Blue Band

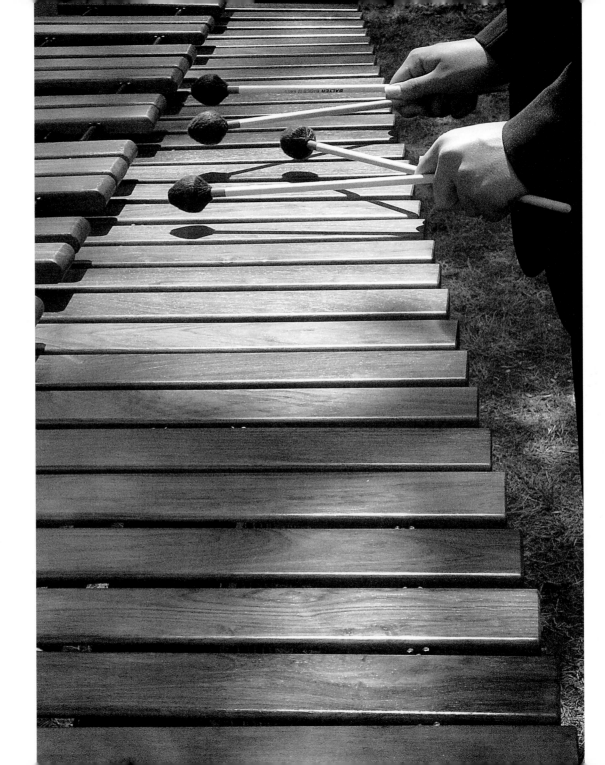

Talent contestant practices marimba

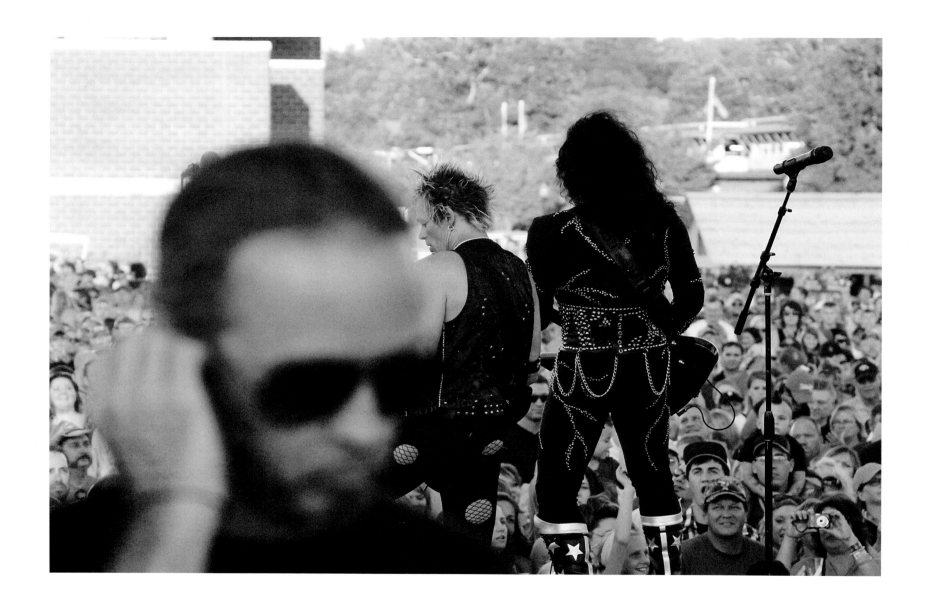

Hairball performs on Budweiser Stage

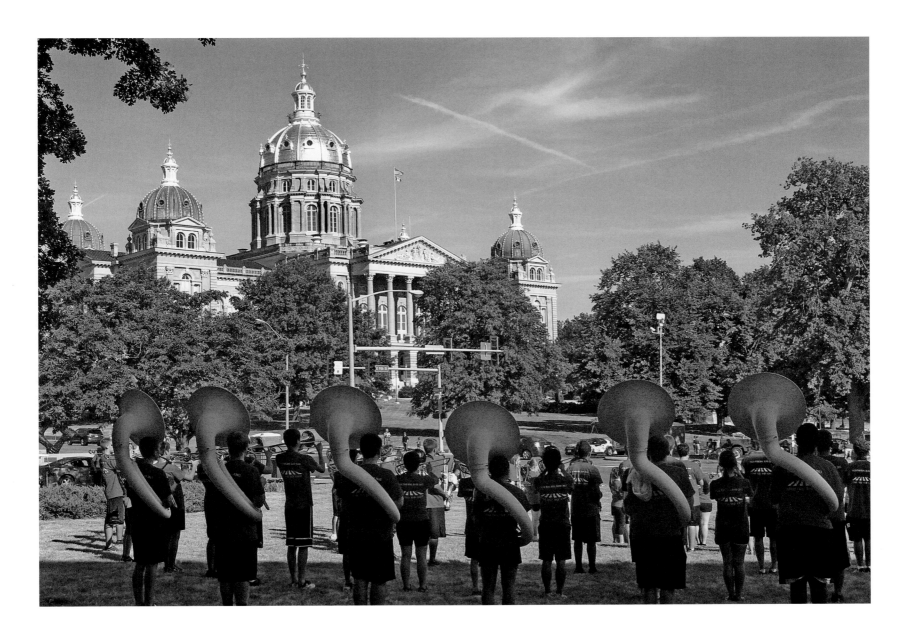

Band prepares for parade

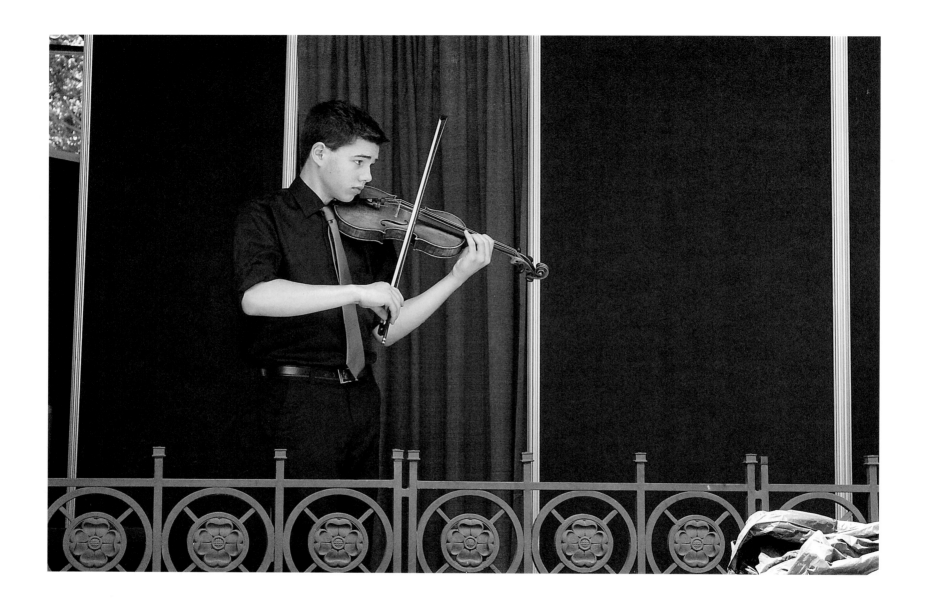

Talent contestant rehearses Sibelius

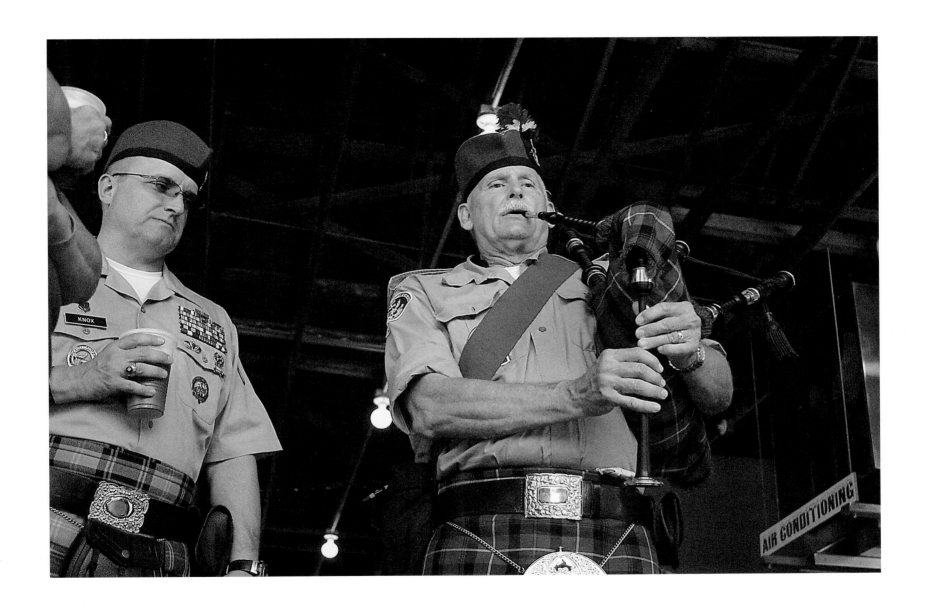

Scottish piper entertains lunch crowd

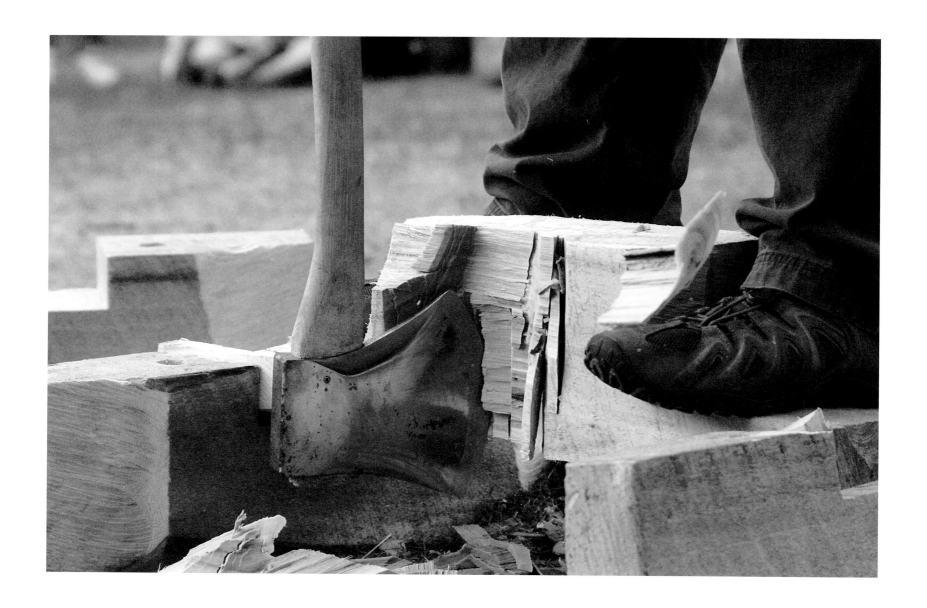

Wood Chopping Contest

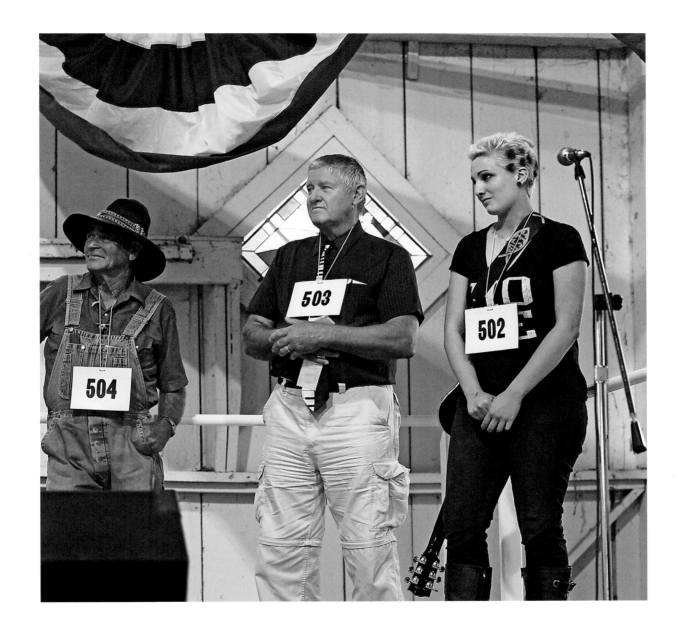

Pioneer Hall yodeling contestants

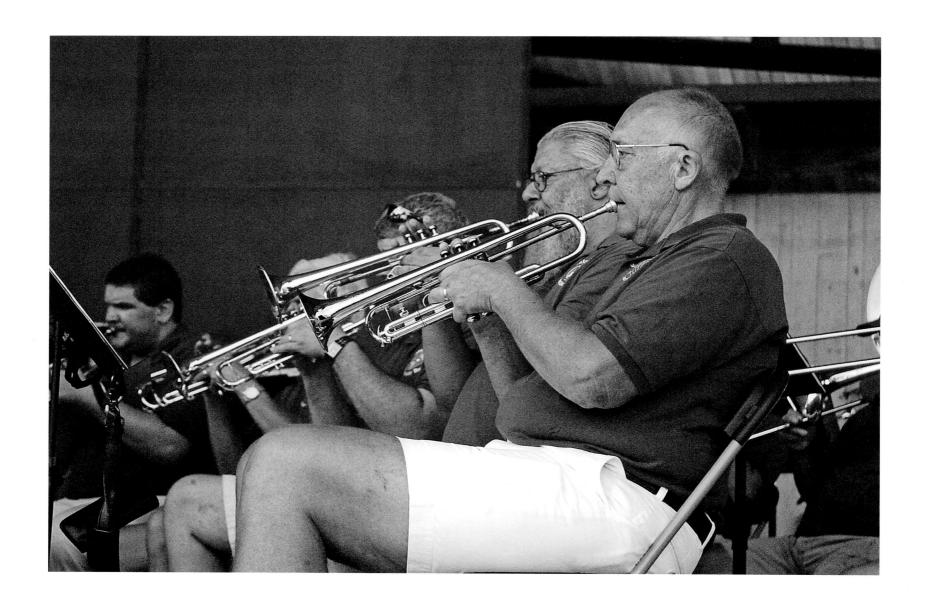

Community band trumpet section

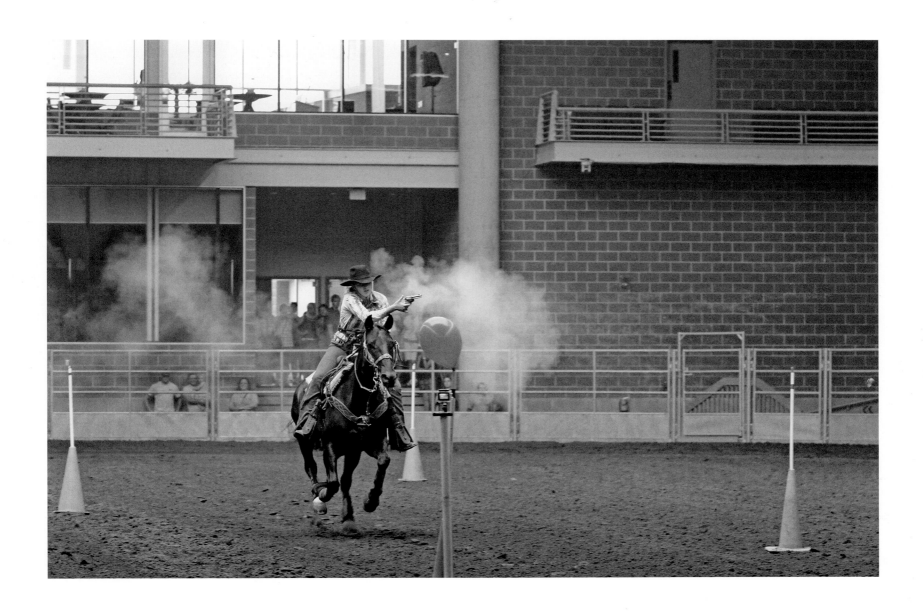

Cowboy Mounted Shooting Demonstration

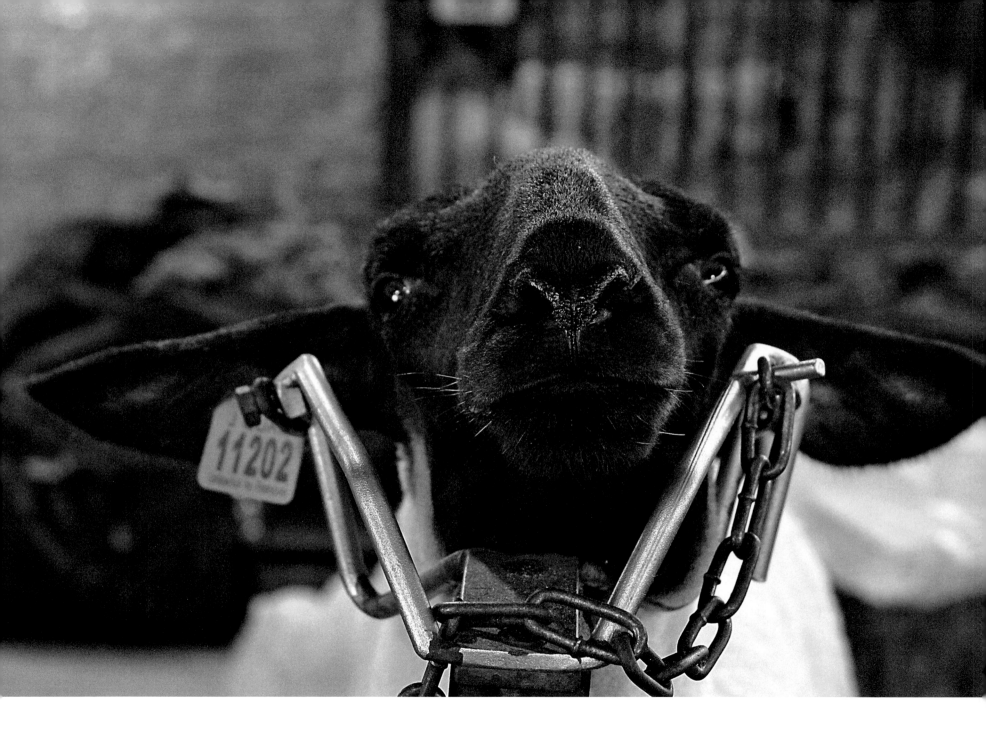

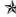

# ANIMALS

Thomas Jefferson dreamed of, and promoted, an agrarian society, a world ruled by those who had an actual stake in the success or failure of the new nation— the farmers, in other words. While society didn't exactly turn out the way Jefferson imagined, the successful production of grain and livestock is nonetheless absolutely vital to the economy of not just the United States but of the world. This is not overstatement, and you sense the truth of it whenever you wander about at the state fair. It's especially apparent in the barns.

You don't have to be a farmer to see that some of the most beautiful, healthiest animals in the world live in Iowa, and much of that is due to agricultural fairs like this one, places where one can view, study, and compare the next big thing, the best market hogs, the finest new lambs, the strongest new horses.

A young woman steps out of the Pioneer Livestock Pavilion on a bright Saturday afternoon, pulling a red wagon in which sits a cage with two of the most beautiful chickens one can imagine, and you find yourself complimenting her on her livestock. She is exiting what is called the FFA Parade of Champions and her gorgeous birds have shared the limelight with other grand champions: cattle, sheep, lambs, rabbits, goats, etc.

As a livestock producer she fully understands that these are not pets. These are animals she has fed and nurtured for months so that they would be ready for market, so she could then sell them for good money.

"By Tuesday night they'll be on someone's dinner table," she says easily, before stepping off toward the poultry barn, her wagon and charges in tow.

The clip-clop of horse hooves along Logan Avenue between the Horse Barn and Sheep Barn turns heads every time, as if you've stumbled heedlessly into some other century, some other way of life. Exalted animals whose use on the farm has long since passed, the horses are led to washing stations where they are shampooed and rinsed. Giant Percherons wait next to adorable miniatures, magnificent Shires next to muscled Quarter horses.

Over in the Swine Barn, a young man uses electric hair trimmers around the ankles of his very patient goat while up the avenue, in the semi-darkness of his spot in the middle of the deep Cattle Barn, a young man brushes his steer with the aid of a set of garage lights.

Determining the biggest ram, biggest boar, biggest rabbit, heaviest pigeon, and largest *whatever* has been a part of agricultural fairs for decades and the practice shows no sign of letting up. And just when you think that perhaps you've seen all of the animals you care to see in a day, you stumble upon a terrific show in the far south side of the Swine Barn, where youngsters are engaged in a goat costume contest.

A child who could be the twin of Margaret O'Brien's little Tootie in the movie "Meet Me in St. Louis" has shown up in a wedding dress. She has dressed her goat as her bridesmaid and she laughs a lot, a full-smile laugh that infects everyone around her.

On the north side of the same building, an ostrich steps back and forth in its enclosure, perhaps agitated by the smallness of her world, or simply wondering why she has been put under the same roof as pigs and goats. She is clearly

Big Bird with an attitude. We haven't really taken yet to producing and eating ostrich on a large scale here in Iowa, but that day may come.

At the 4-H Building, a photo of a 4-H member's beautiful dog has earned a blue ribbon and, while every 4-H kid takes pictures of his or her pet, this one stands out. Carousel horses gallop round and round, up and down, as they have for centuries, and up at Pioneer Hall, high on a wall, a stained-glass window depicts a dove with an olive branch, a symbol well-known throughout the world: the symbol of peace.

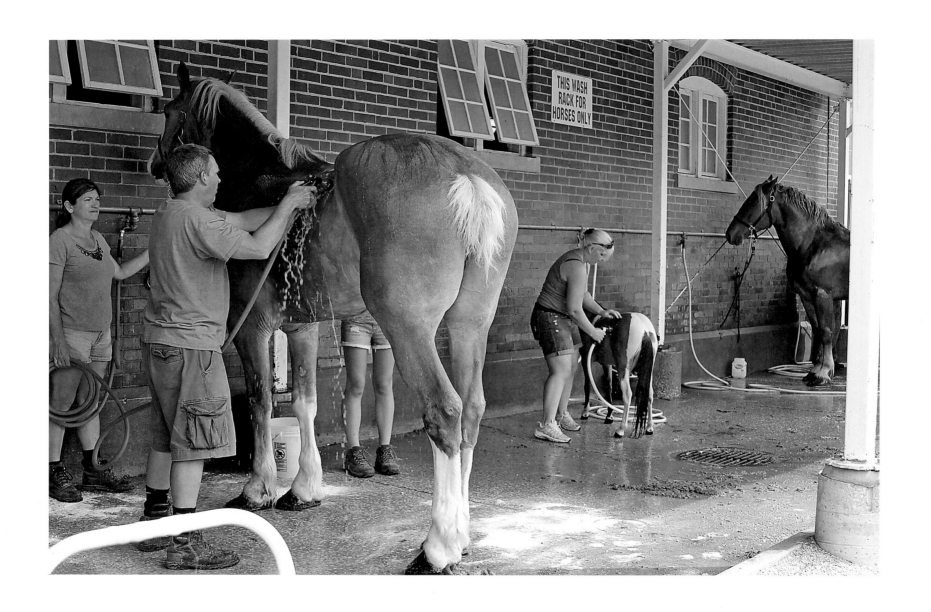

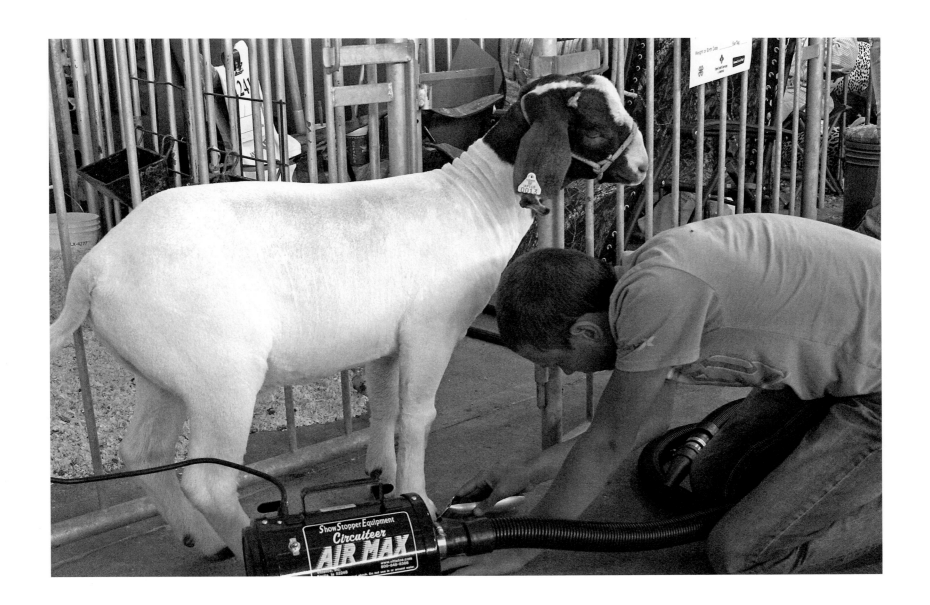

Goat receives an ankle trim

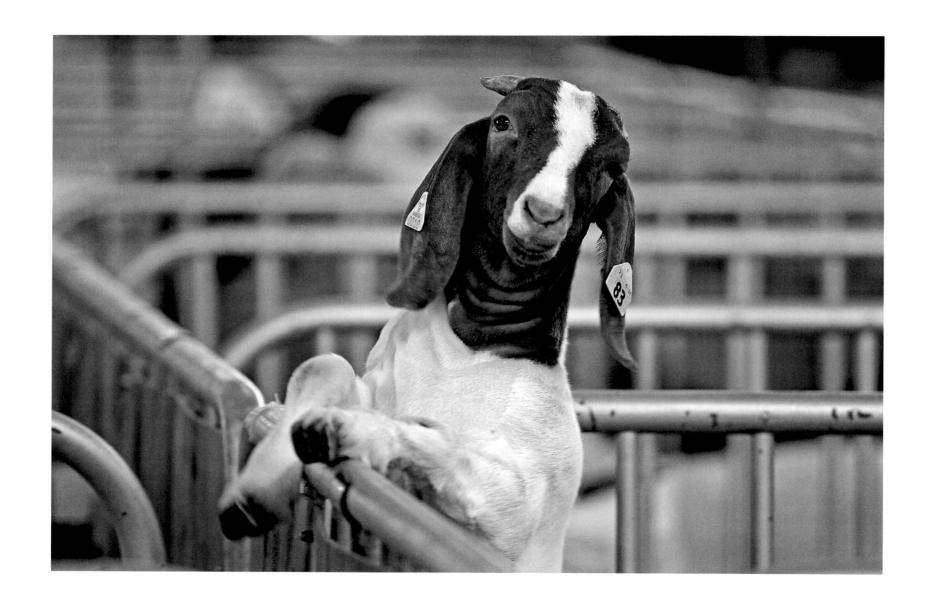

Goat looks on casually

Back to the stables

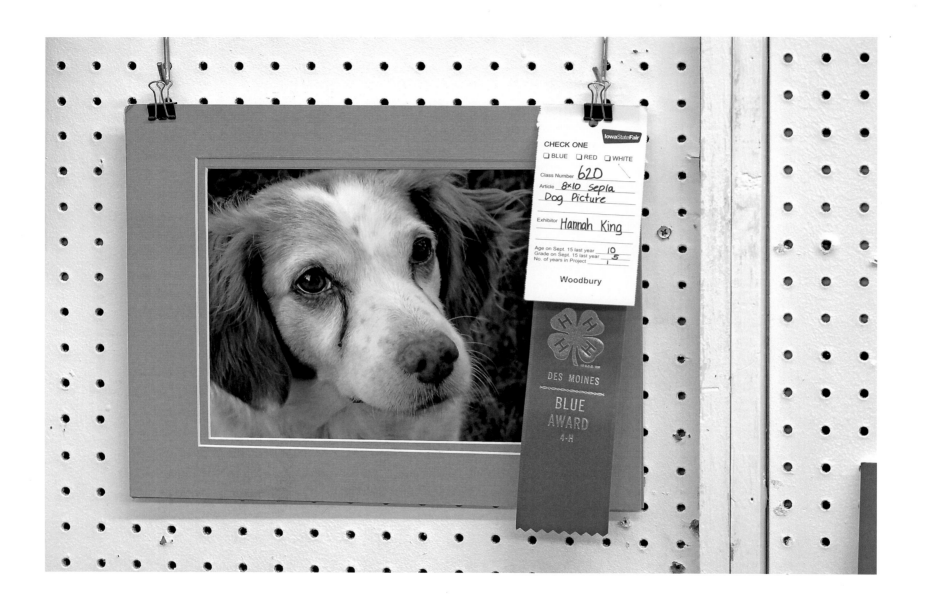

The ribbon/tag reads:

Iowa State Fair

CHECK ONE
☐ BLUE  ☐ RED  ☐ WHITE

Class Number 620
Article 8×10 sepia
Dog Picture

Exhibitor Hannah King

Age on Sept. 15 last year    10
Grade on Sept. 15 last year    5
No. of years in Project    1

Woodbury

DES MOINES
BLUE
AWARD
4-H

Winning 4-H photograph

Very clear warning

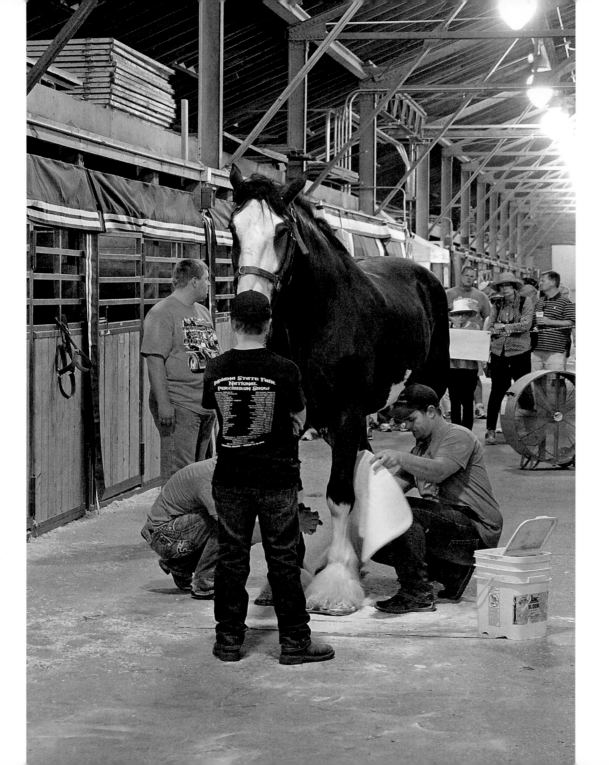

Work horse receives ankle wrap

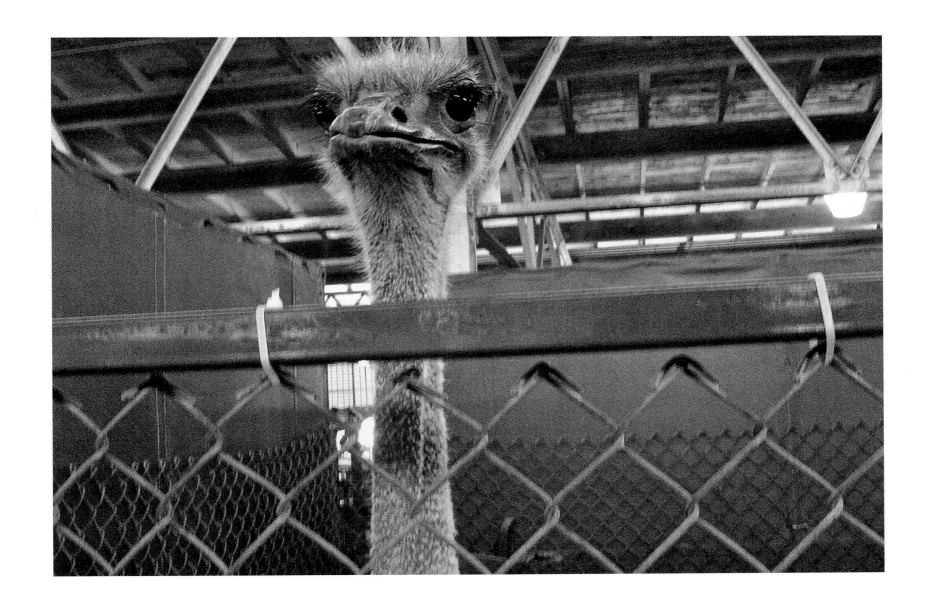

Ostrich shows curiosity

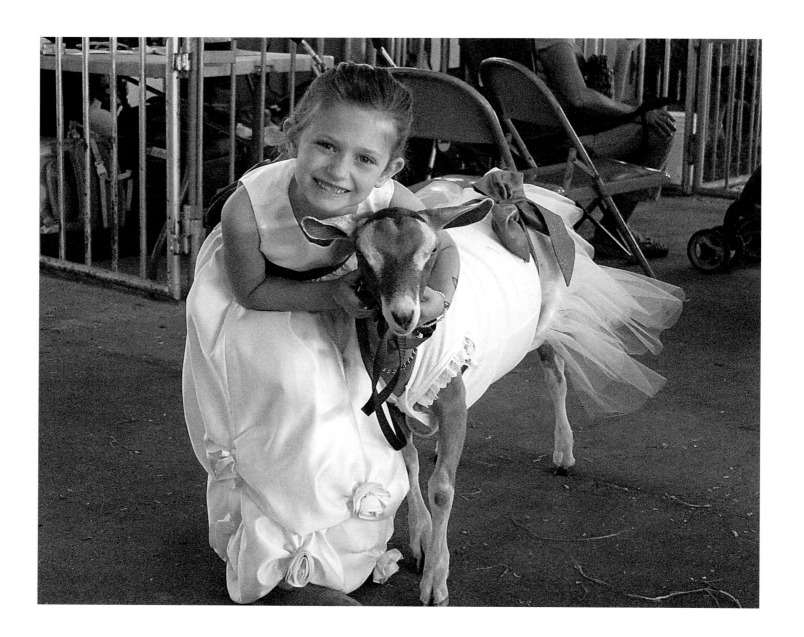

Dairy Goat Show: costume class

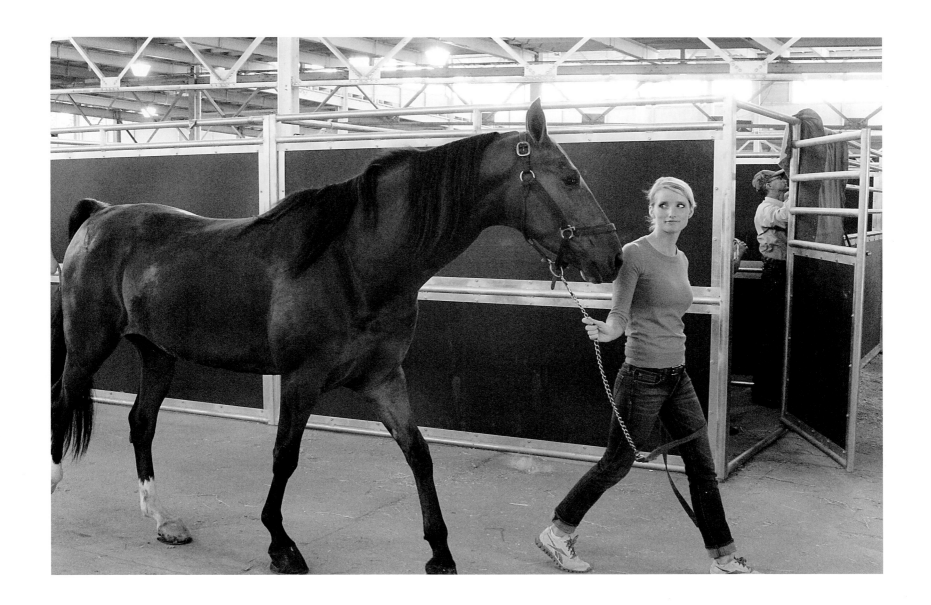

To a trailer for the trip home

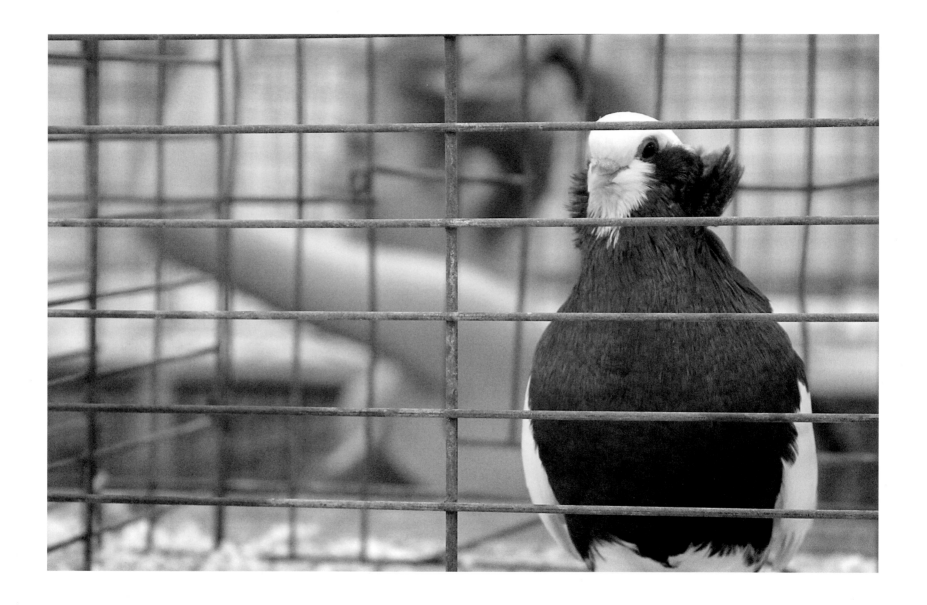

Puffed-up pigeon

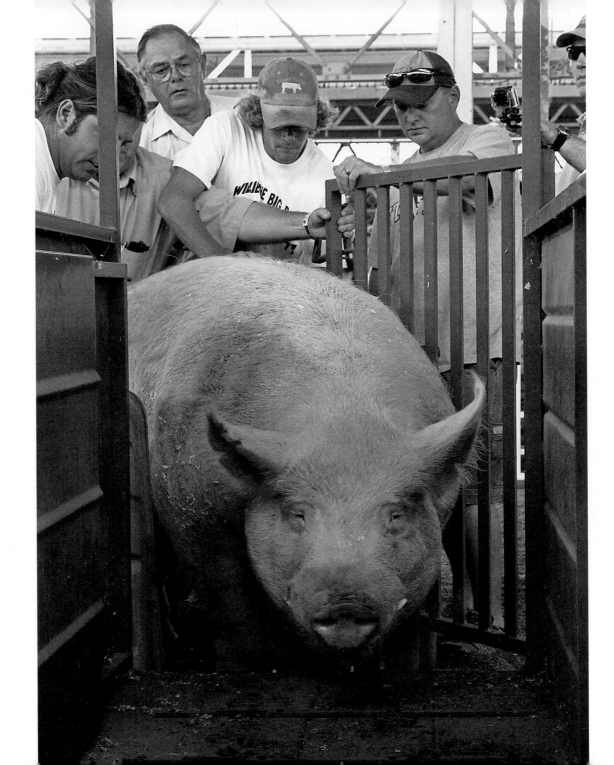

Big Boar Contest

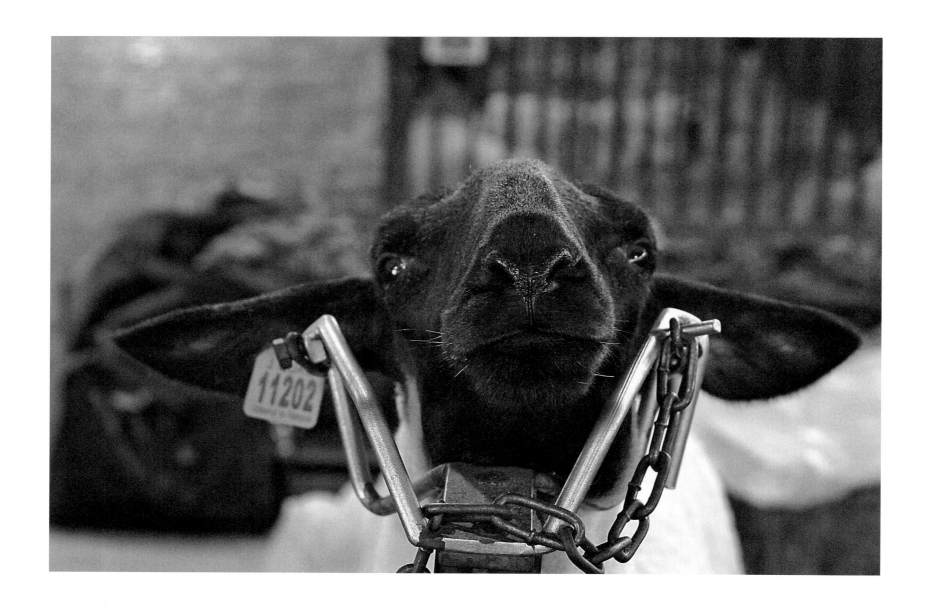

Sheep in restrainer awaiting trim

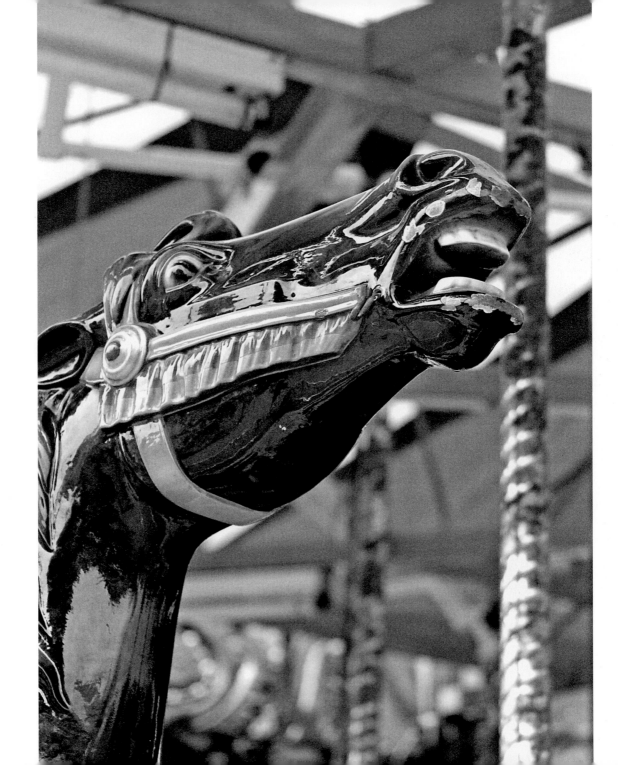

Carousel horse in a hurry

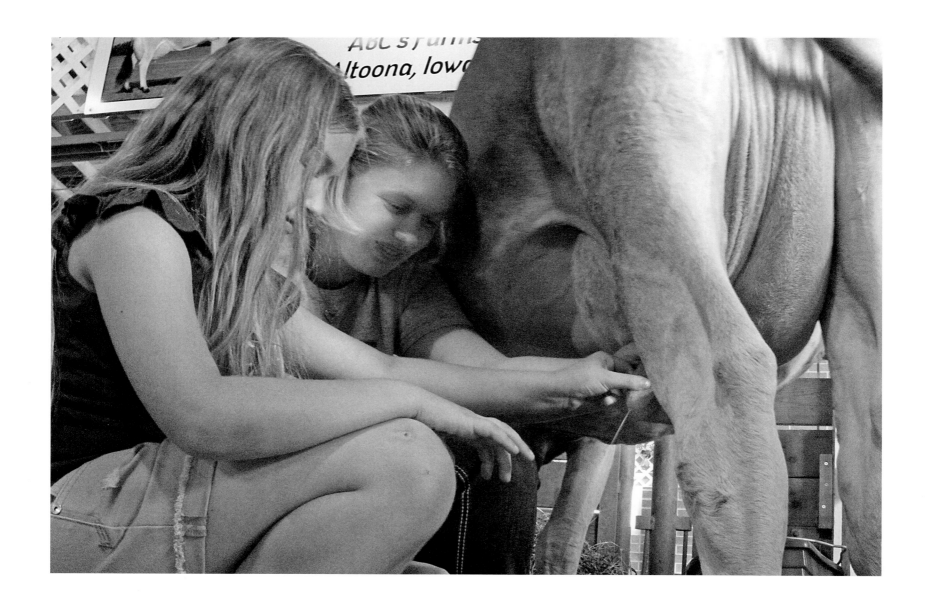

I Milked A Cow participants

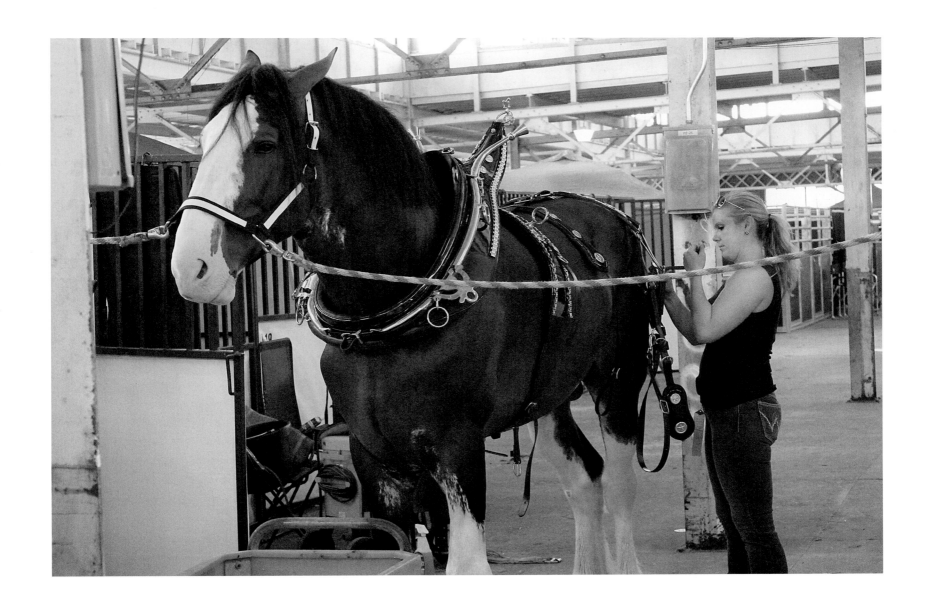

Horse being prepared for show

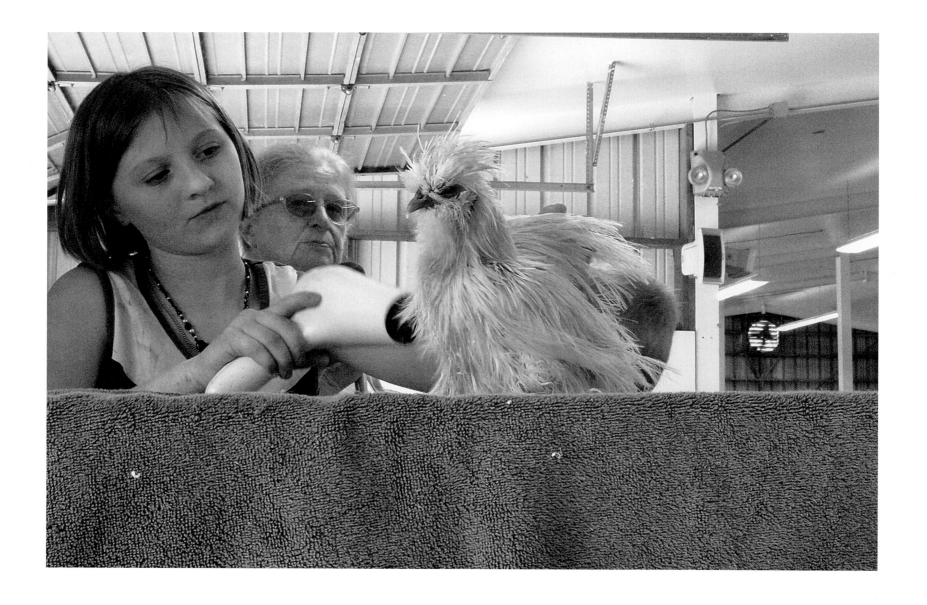

Chicken Washing & Blow-Drying Demonstration

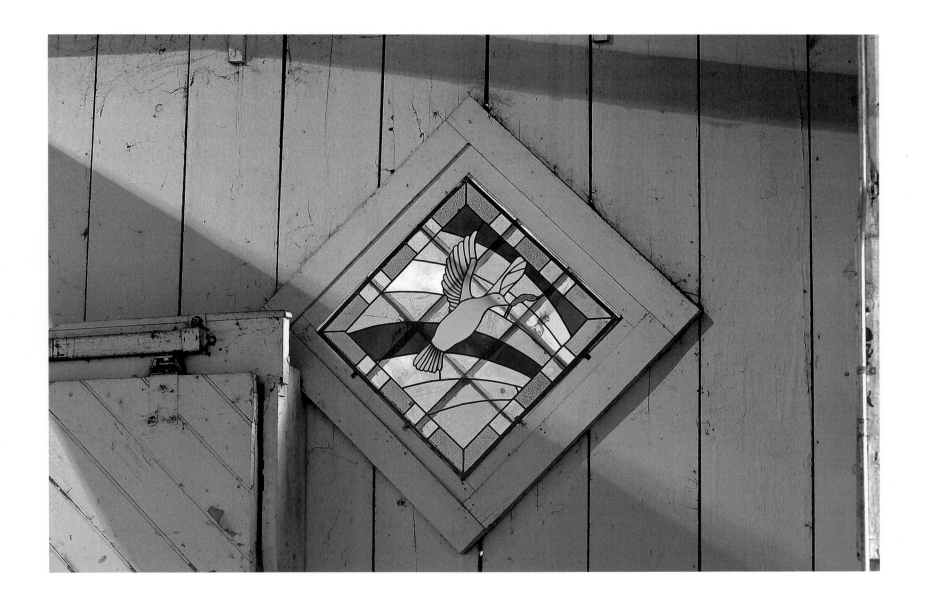

Peace dove window, Pioneer Hall

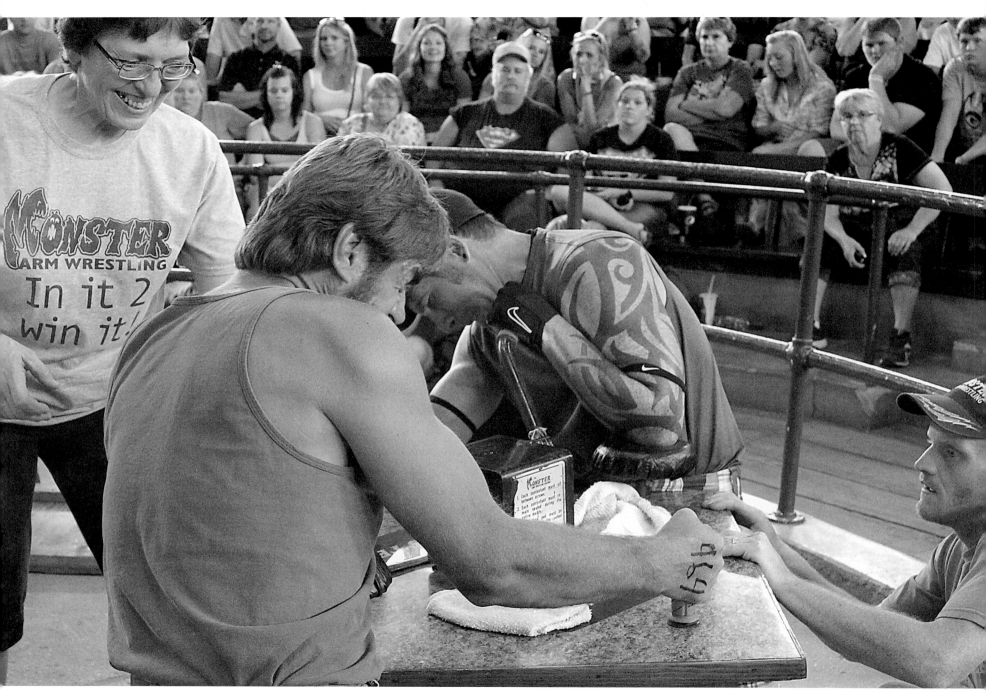

Monster Arm Wrestling Tournament

## COMPETITION

At a state fair virtually everything involves competition, from the livestock halls to the 4-H buildings, from cooking and baking to arm wrestling, from the newest whatever-on-a-stick to statewide talent searches, from photographs to quilts, and from cross-breeding to genetics.

In the much-appreciated air conditioning of the Elwell Family Food Center, sustenance becomes art. The best cooks and bakers from around the state bring in their best work, be it a much-improved version of grandma's cherry pie, with cherries from Door County, or much-favored rolls with cinnamon from exotic Ceylon, a spice Marco Polo likely carried in a dusty leather satchel on his travels along the Great Silk Road 700 years ago. It's all here.

The only, and perhaps most important, ingredient missing is the ability to actually watch the making of the delicious entries. Perhaps one day there will be holograms of the cooks and bakers back in their Iowa kitchens, whipping up batches of chocolate chip cookies, pulling ingredients from a century-old pantry, humming along with an old radio where Nat King Cole sings about lazy, hazy, crazy days of summer.

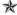

In the Pioneer Livestock Pavilion, dairy cattle and, later, beef cattle are pushed, pulled, and generally paraded around the dirt floor and assessed by judges whose own cattle days may be far distant. Animals weighing more than half a ton are being led by young 4-H and FFA members, some of them lucky to weigh 100 pounds. All are well aware of the heft and power of their charges, yet they seem entirely comfortable with the responsibility. These are lessons hard-taught in barns, not in our schools.

And perhaps there is a tension at some of these events that only a few parents see, something other than the competition. Like when their daughter glances down the row of beef cattle being held in place by other youth from all over the state and knows she has waited all year to see some boy from a far-flung county in western Iowa.

Novels could be written about this stuff. He wants to be a farmer, like his own father, and his father before that. You know, Century Farm and all that, but she entertains Milky Way dreams and sees a different trajectory for her life. So a few days at a state fair together can be both a beginning and an end, a place of great passion and shoulder-dropping emptiness. But it's OK. These things are understood. You can practically add a soundtrack, maybe Ella Fitzgerald singing about the painted swings of a fairground, and how "these foolish things remind me of you."

On a warm morning in the far southwest corner of the grounds, muscular men and women gather for a weightlifting contest. Serious contenders, these are not people toward whom you'll want to kick sand. Human strength has been a source of competition for thousands of years and, clearly, at state fairs it's no different.

Beauty and charm also have a place at the fair, the fairest of the fair and all that. Somewhere in the neighborhood of 100 young women, each representing

a smaller fair elsewhere in the state, compete to become the latest Iowa State Fair Queen.

The first few days prior to the crowning of the queen, the young women are everywhere, good-will ambassadors who, unlike the rest of us, happen to wear shoulder-to-waist sashes and occasionally break into the opening Rodgers and Hammerstein musical number from the 1945 movie "State Fair."

There is something exquisitely right and grin-inducing when suddenly, from the far corner of the Varied Industries Building, you hear dozens of young ladies in full-throated happiness sing, "Our state fair is a great state fair / Don't miss it, don't even be late."

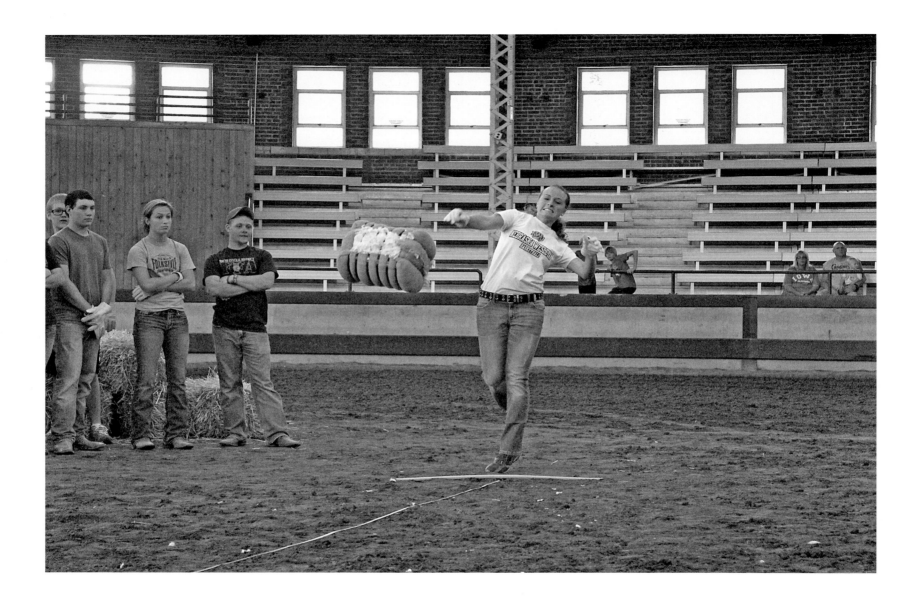

Young Farmer's Challenge: hay bale toss

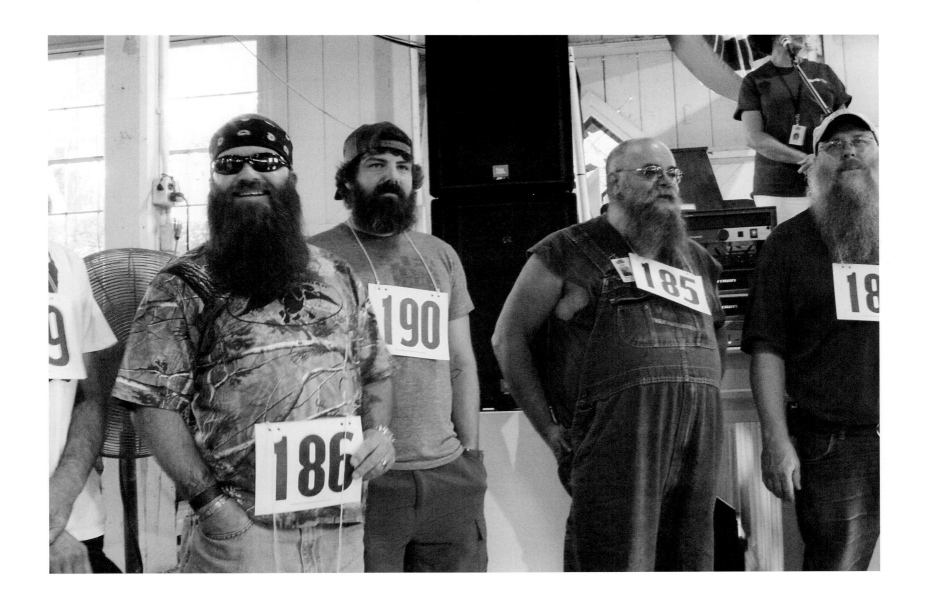

Beard Growing Contest

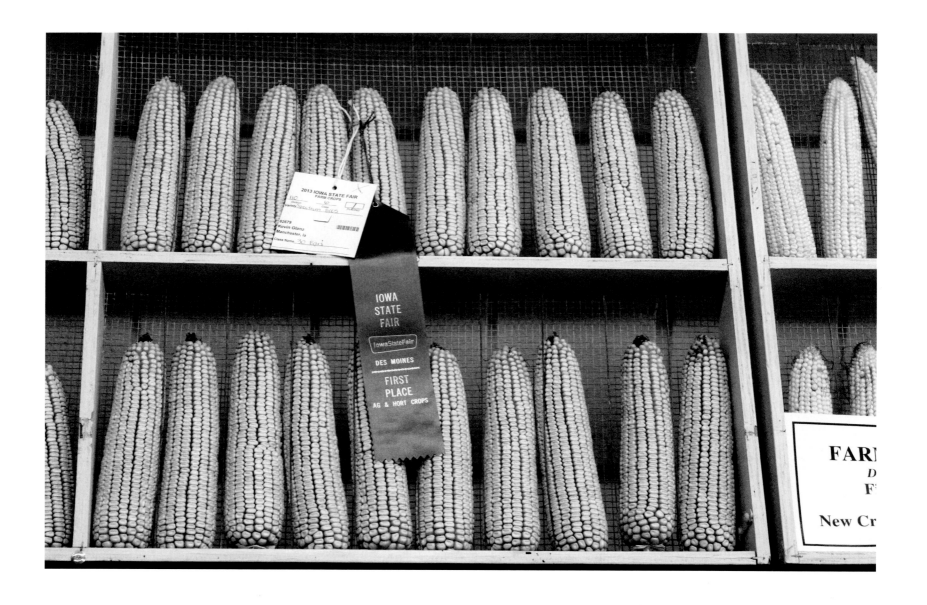

Best corn in Iowa

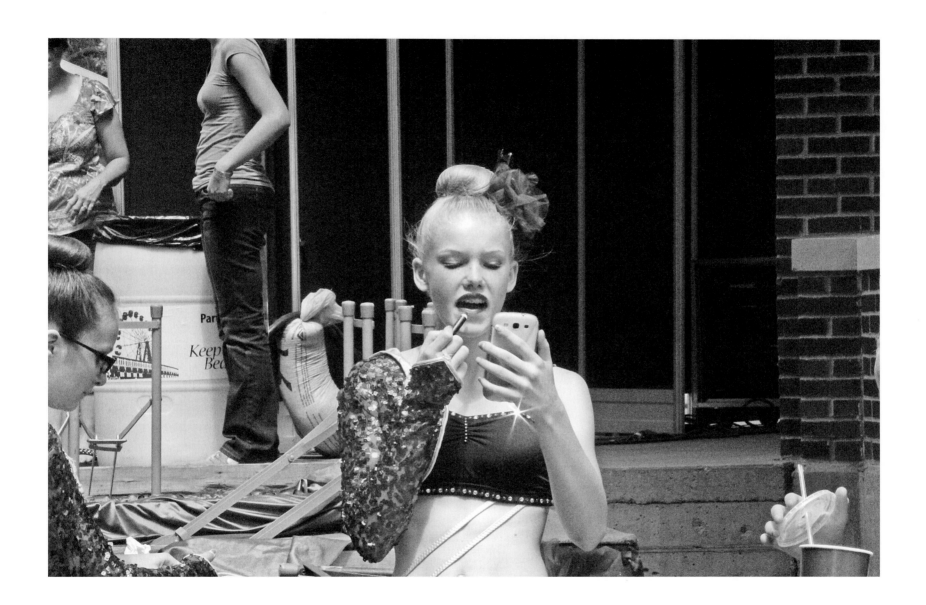

Preparation for Bill Riley's Talent Search

Youthful chess competitor

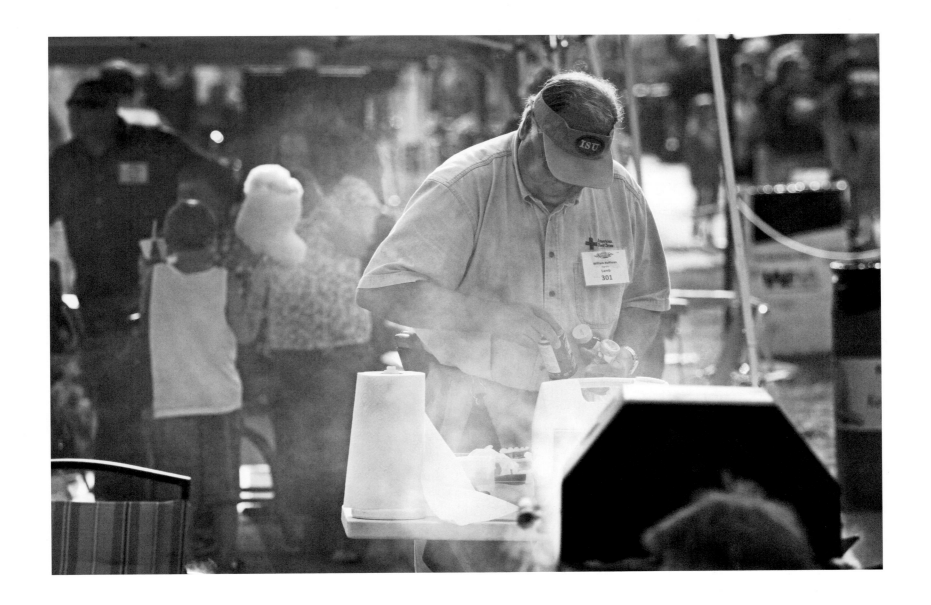

Farm Bureau Cookout Contest

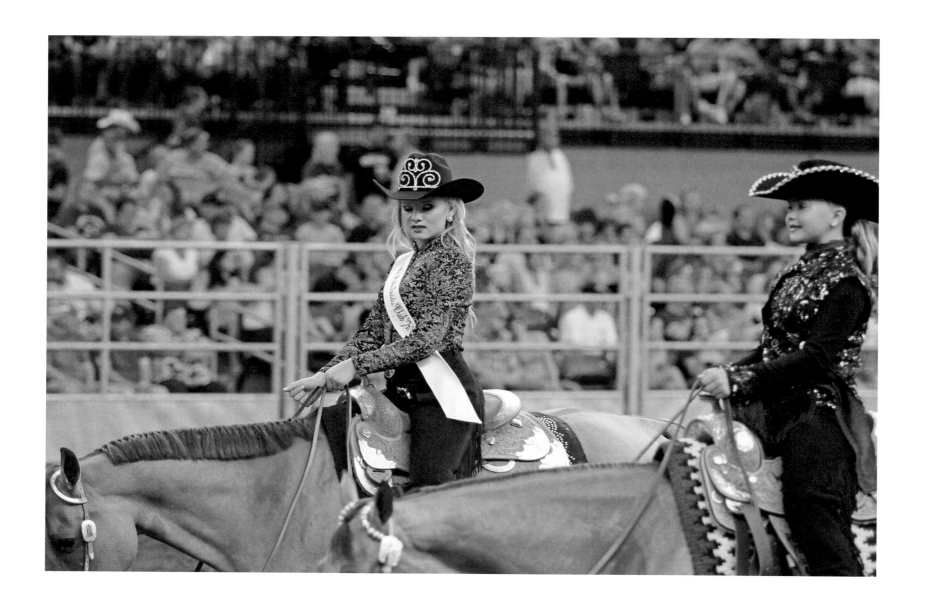

Young Cowgirl Queen contestants

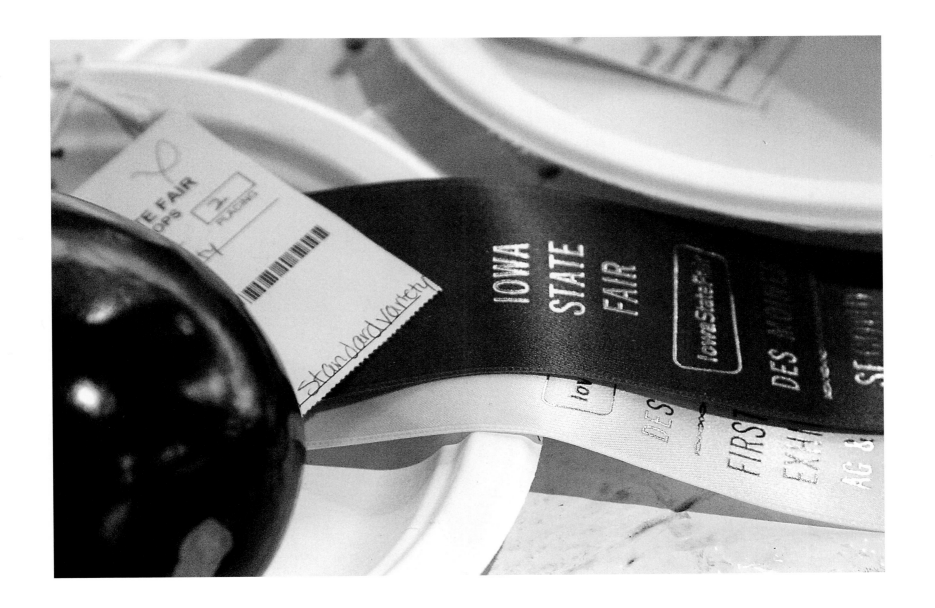

State Fair ribbon

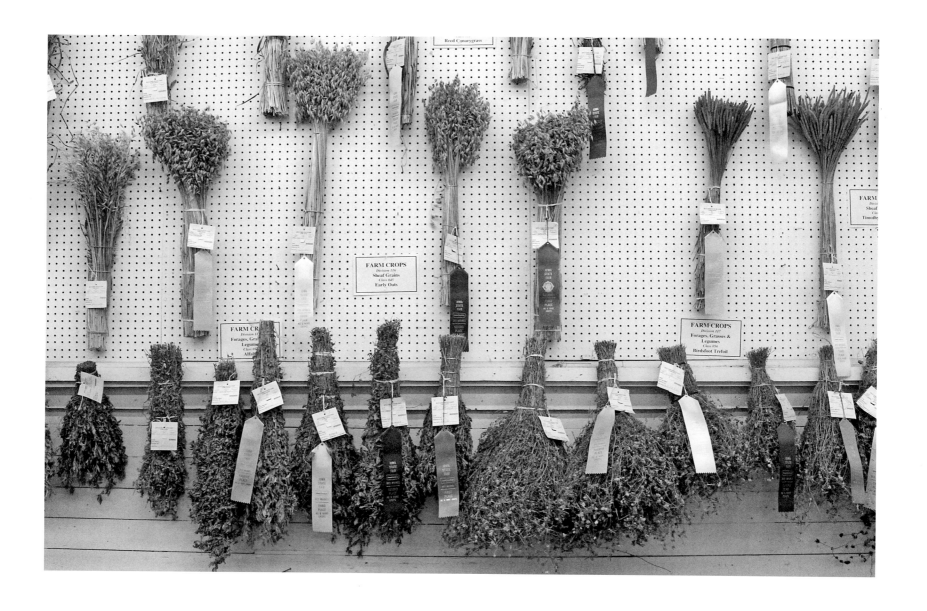

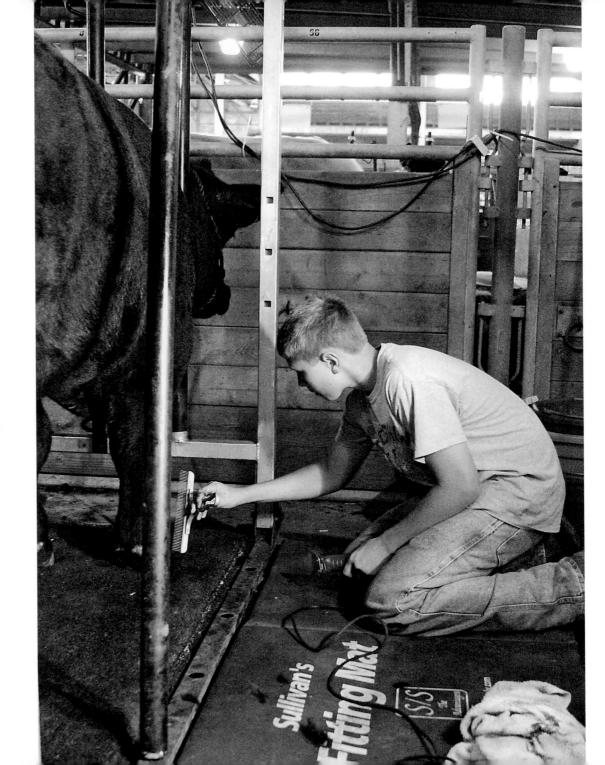

Cattle being brushed before show

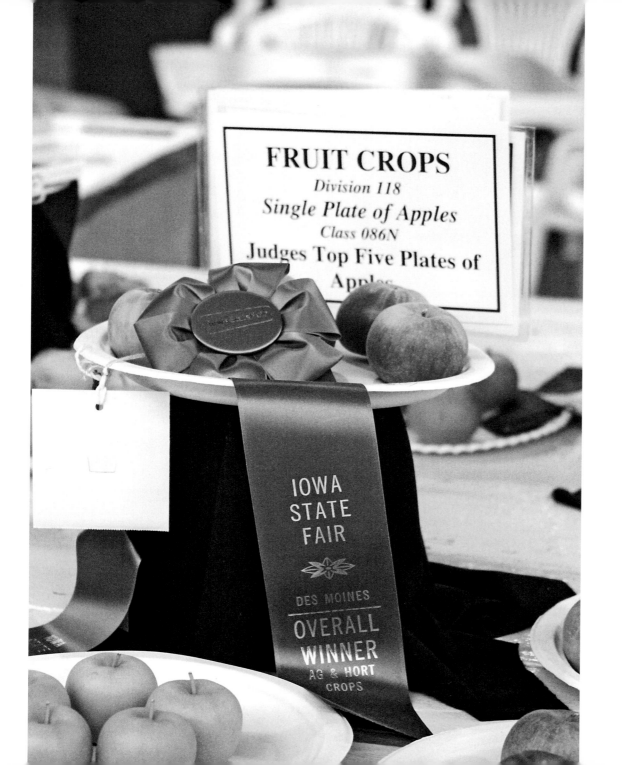

Top plate of apples

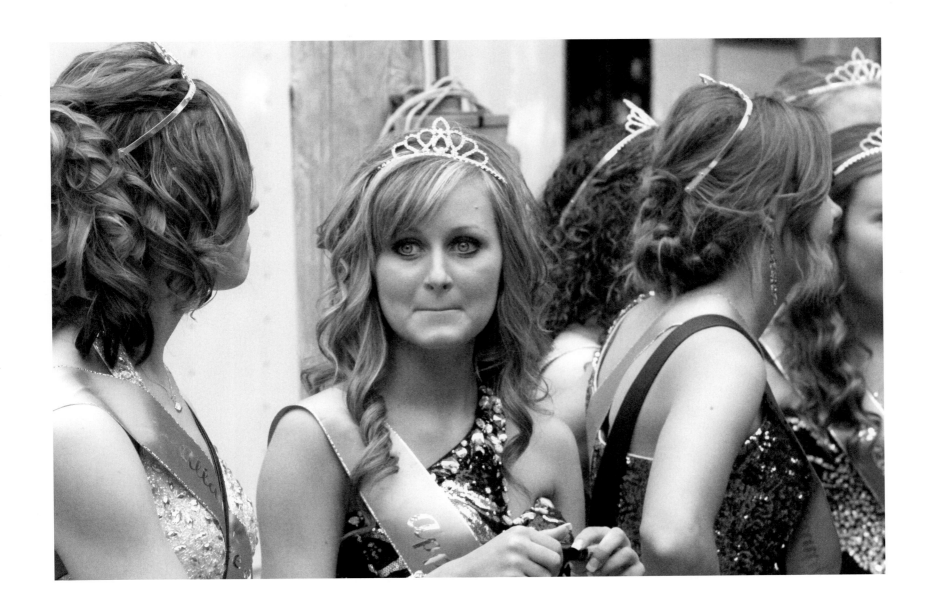

Pursed lips, Fair Queen Competition

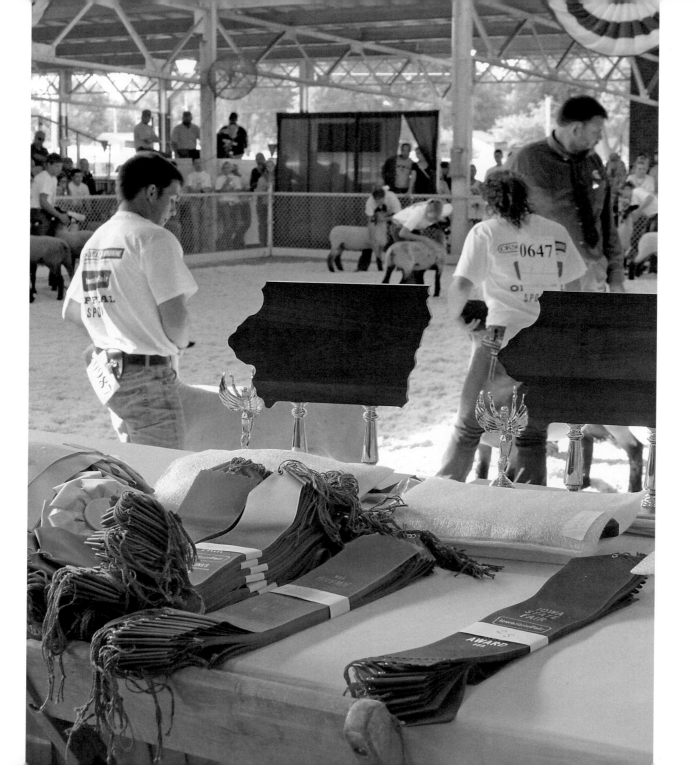

Ribbons and trophies

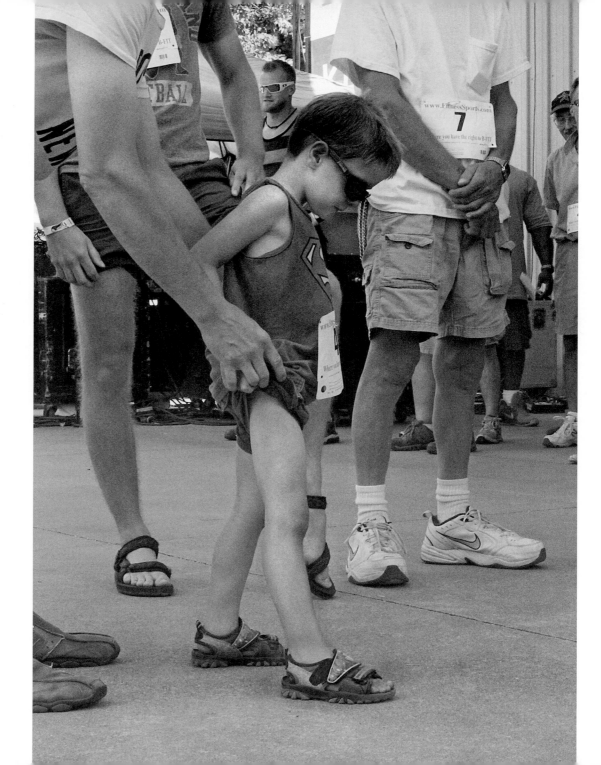

Young competitor, Mr. Legs Contest

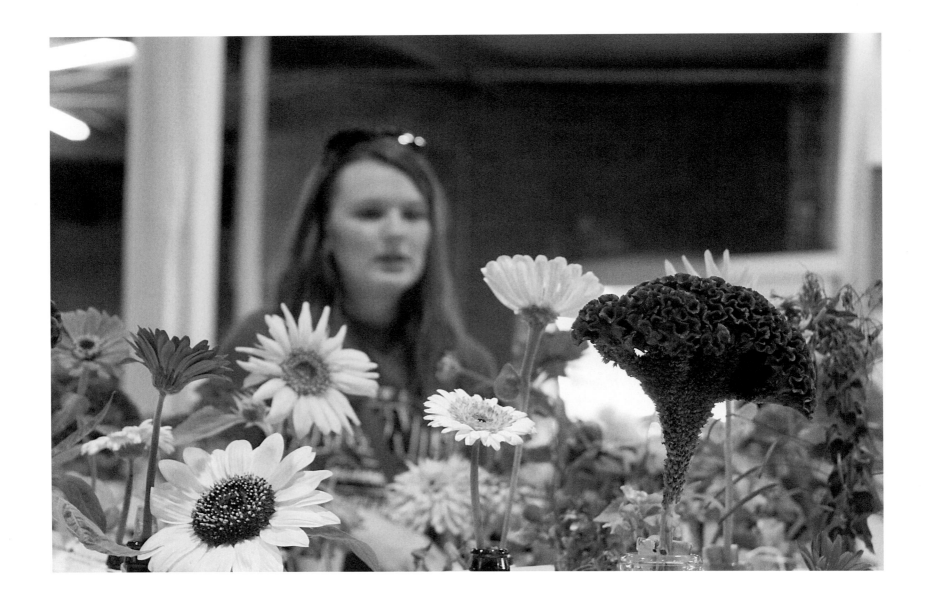

Best flowers around

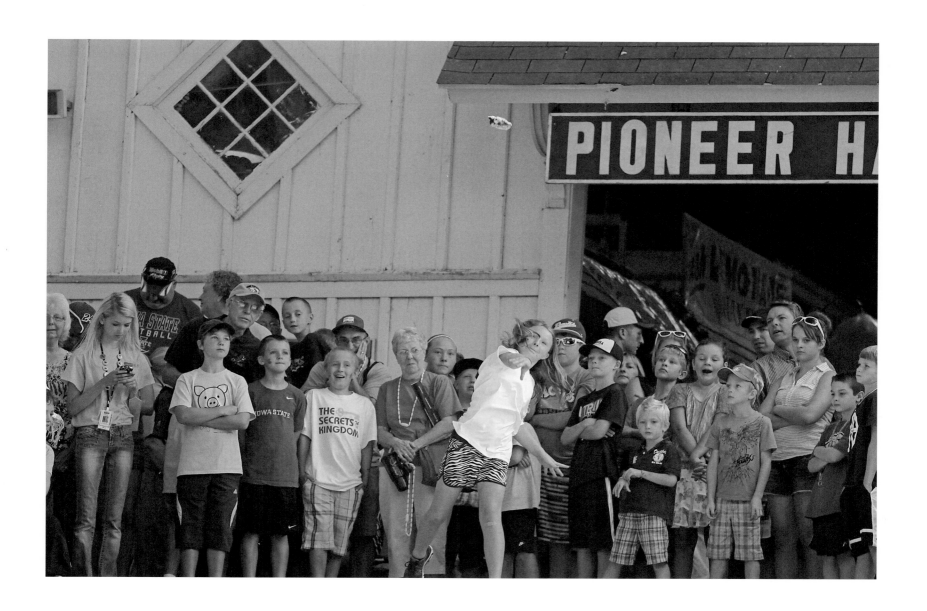

KRNT Cow Chip Throwing Contest

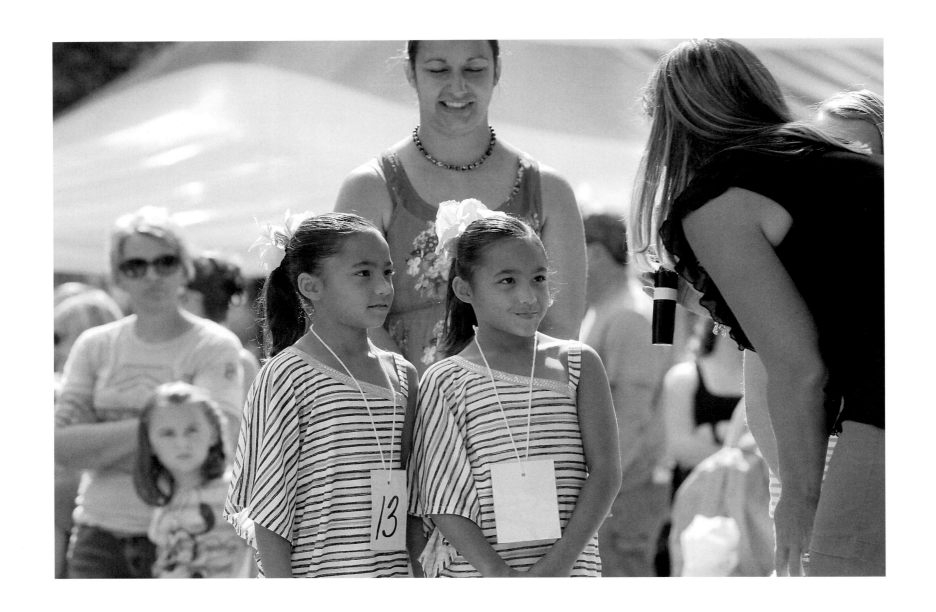

Twins, Triplets & More Contest

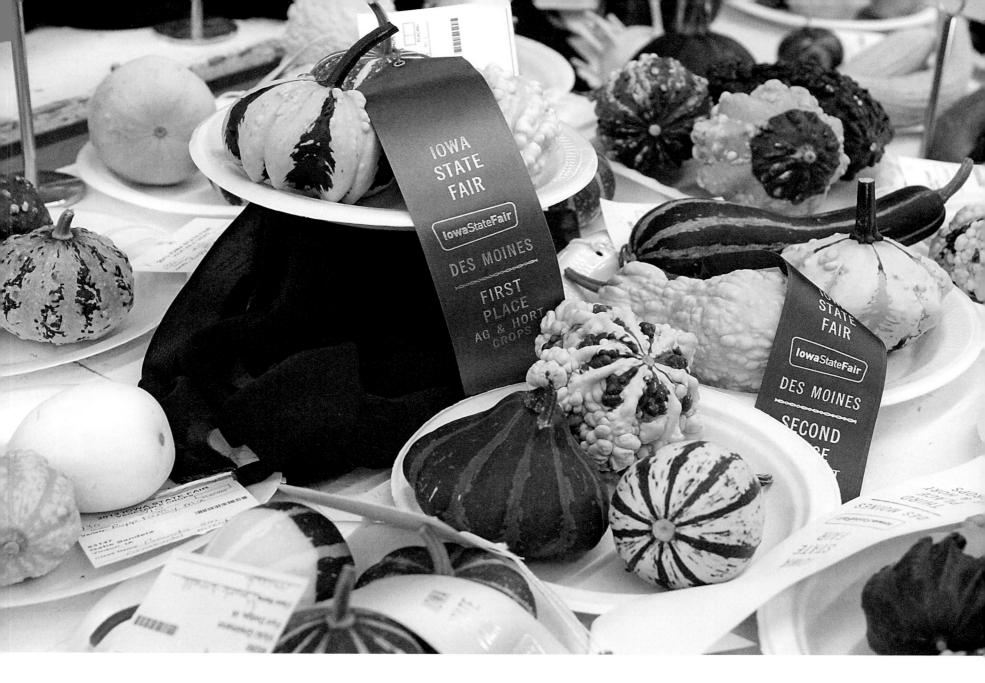

First and second place gourds

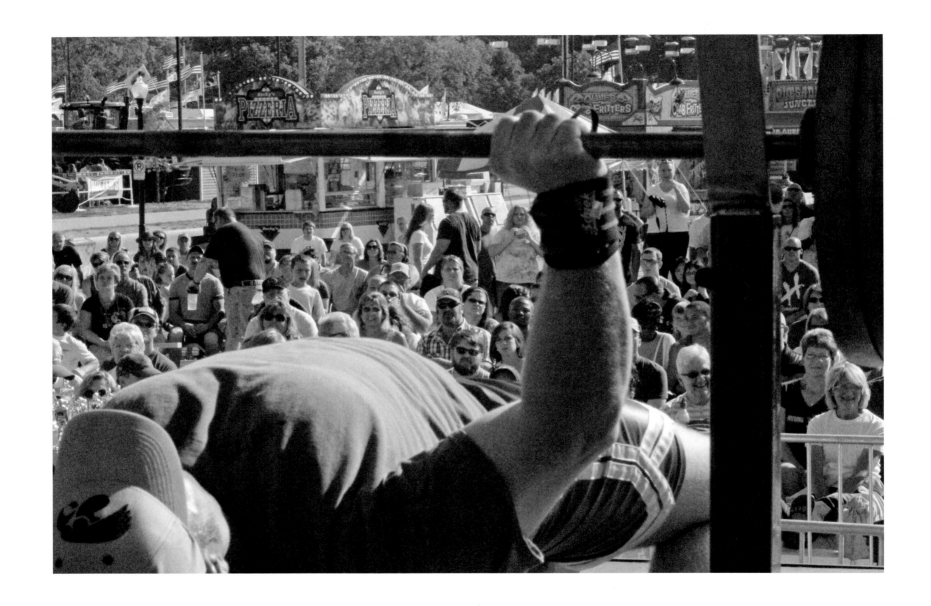

Bench Press/Deadlift Competition

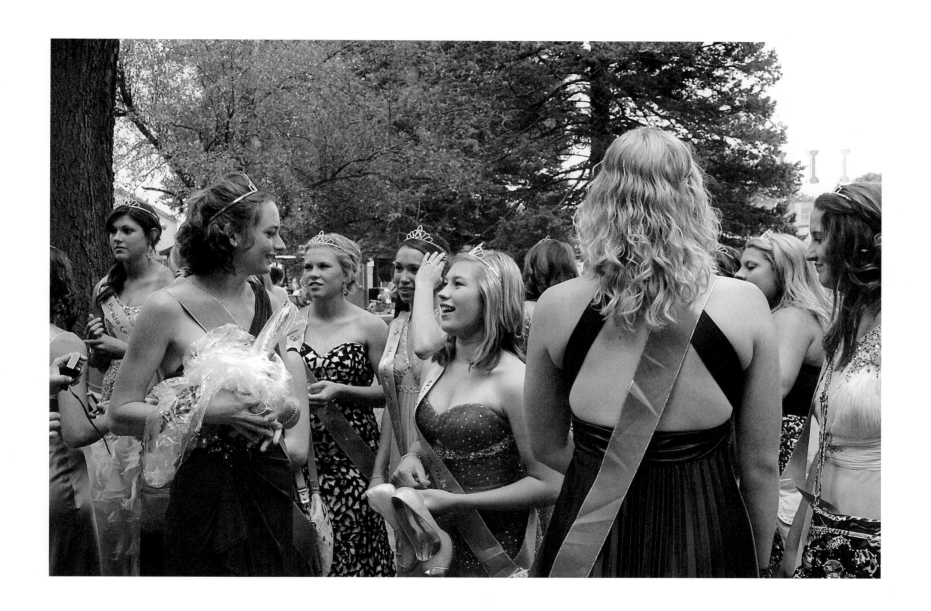

Iowa State Fair Queen contestants

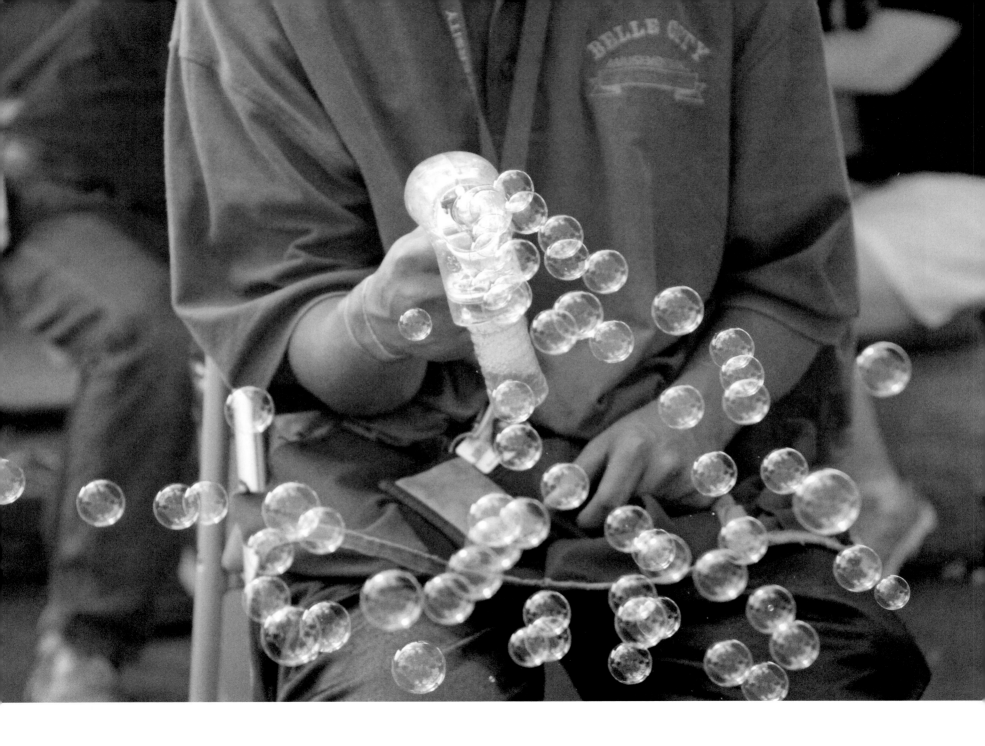

# COMMERCE

The Iowa State Fair is, at its essence, about agriculture. And agriculture, of course, is about commerce, about selling livestock, grain, farm implements, tractors, and land, then selling others on the bright future of these things. This explains why, on a warm August morning, a busload of farmers from western Australia roams the livestock barns looking for what's new in sheep, cattle, and goats. And it's why livestock auctions occur on the grounds almost daily.

Area auctioneers who likely still call themselves Colonel something-or-other show up in white cowboy hats to empty each barn of its temporary animal boarders, most selling for much higher than current market value. These creatures are the best of the best.

And it's at the Varied Industries Building where salesmanship of all varieties takes place: a blurred picture of long days, concrete flooring, and mostly indifferent customers, unless something free is offered, like the temporary Herky the Hawk tattoos applied by chipper University of Iowa cheerleaders.

The salesmanship here is only slightly less subtle than that of the pitchmen on the Midway. You know the types, challenging you to shoot a hoop or throw a baseball, but the mission is the same; find a buyer. Whether it's a couple selling

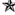

87

tourism in Madison County, a woman offering to detoxify your body by soaking your feet, or two guys nattering on rapturously about mattress firmness, it's all about sales.

Governor Terry Branstad, perhaps the state's best salesman, also puts in many hours at his booth, selling human contact over politics. He first attended the state fair as an adult. When he was growing up, he never made a trip to Des Moines from the family farm in Winnebago County except to play baseball in the state tournament as a sophomore. These days he can't get enough of it. "The Iowa State Fair is Iowa at its best," he says enthusiastically while greeting people in the aisle outside his booth in the Varied Industries Building. "The fair is FFA and 4-H, and it's showing their talents." Sold.

Off to the side of the far aisle a salesman talks to a customer about satellite dishes. The cheerful-looking customer seems right out of "Henry IV," so like a guy named Falstaff who described himself as goodly and portly. That's him, if he would simply remove the very odd stuffed-shark hat.

By late afternoon, perhaps you stroll down Rock Island Avenue where beverage servers in the Iowa Craft Beer Tent are busy doling out plastic cups of beer at the cost of an imported six-pack back home. The woman serving you smiles and you're sure you knew her once, a long time ago, in some other place. She's pretty, and all sorts of sentimental muck echoes around your head and maybe, just maybe, for just a moment you're back with your old buddies on leave in Munich under the bright canopy of an Oktoberfest tent, back when the world seemed to make more sense. You can't beat the avenue for simple pleasures like enjoying a taste of hops and a view of the passing world.

Just south of the Varied Industries Building is a road less traveled, a small path leading through the middle of the Machinery Grounds, where farm machinery dealerships set up showcases of the stuff they sell, from t-shirts with logos to livestock fencing to farm equipment costing hundreds of thousands of

dollars. If you're looking for a quiet spot in the cacophony of the fair, this might be the place, one where you can pick up a heavily-sugared lemonade and sit for a while.

Up the hill in the Agriculture Building, a line forms daily to pick up hard-boiled eggs-on-a-stick. Egg producers are happy, customers enjoy a flavorful snack, and somewhere chickens are contacting their union. It's all about commerce.

Towering over the fairgrounds is a Jack-in-the-Beanstalk-sized wind generator, an odd name for a windmill that does not, in fact, generate wind. Be that as it may, it's a sign of what Iowa has been up to for a number of years; Iowa reportedly produces 20 percent of its electrical energy by harnessing the wind, a remarkable figure by any estimate. This particular wind generator is a testament to the new century's ingenuity and commerce, a beautiful rhythmic whoosh of natural force and power atop a hillside right out of an Ansel Adams photograph, full-grown trees and a Sky Glider below, cumulus clouds and a cerulean blue above.

From plastic handguns that spew bubbles for children, to the harnessing of the Ben Franklin discovery that keeps the lights on out in the barn, this is commerce on display, both small and large.

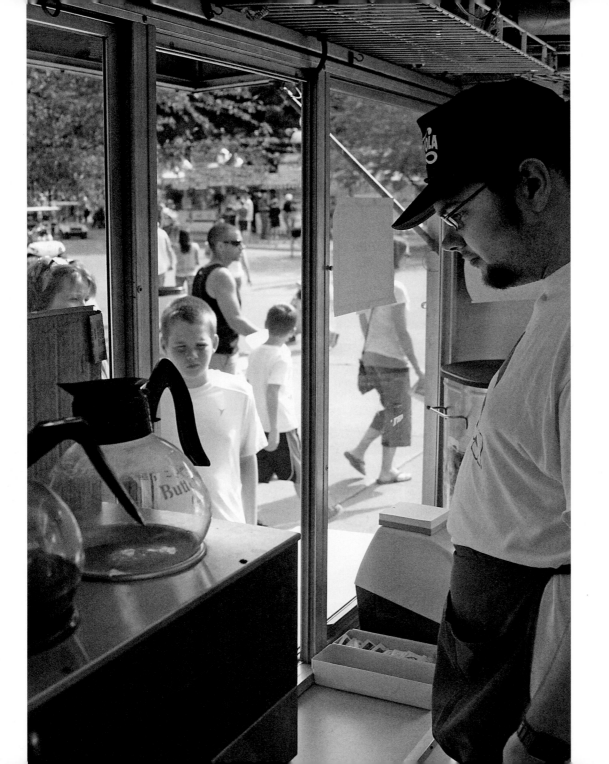

Worker makes more coffee

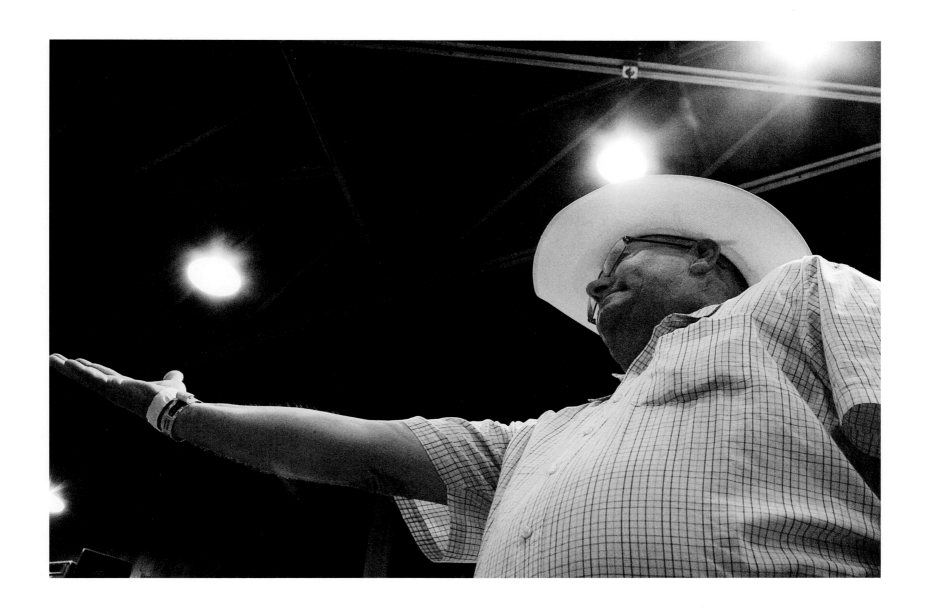

Auctioneer, Governor's Charity Steer Auction

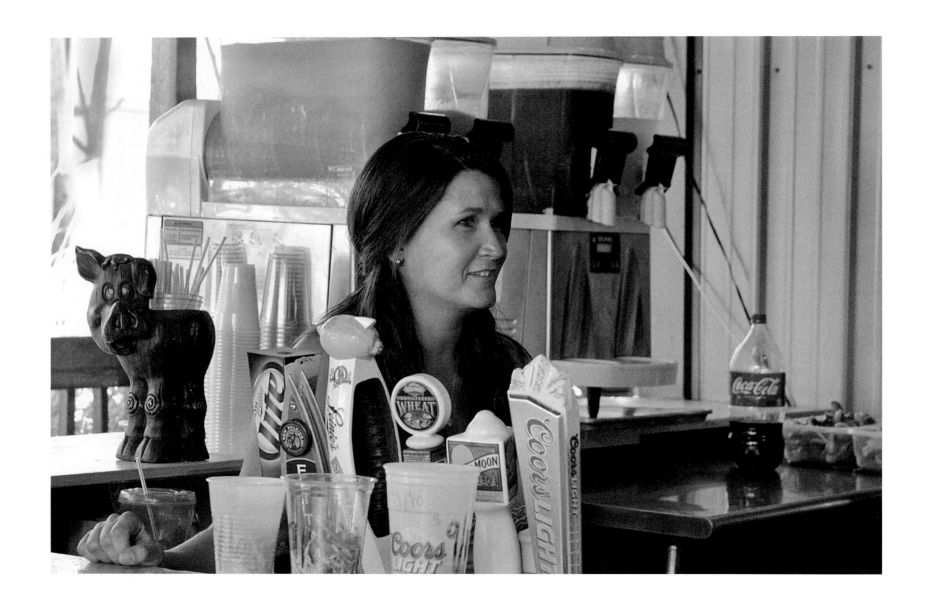

Beverage server awaits next customer

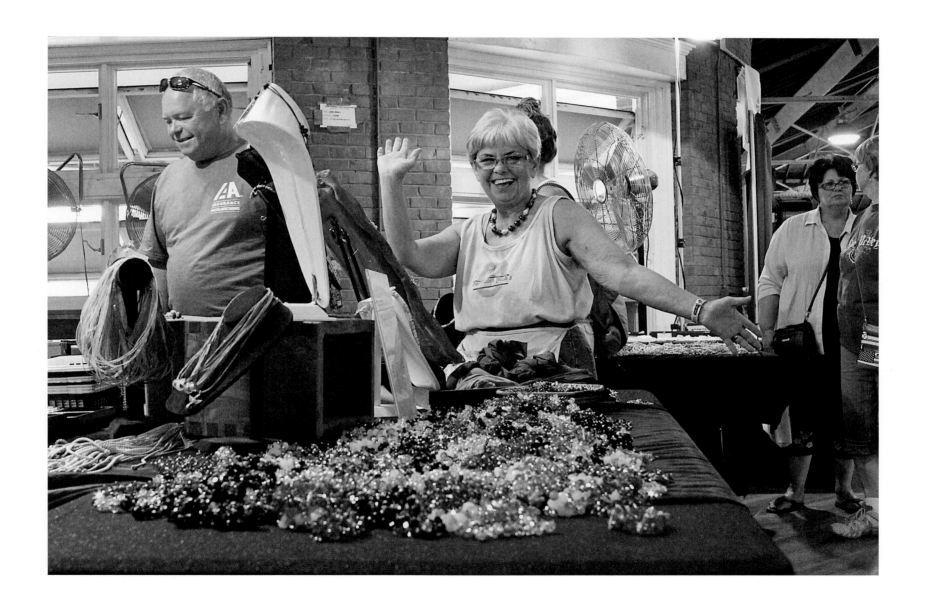

Jewelry saleswoman shows style

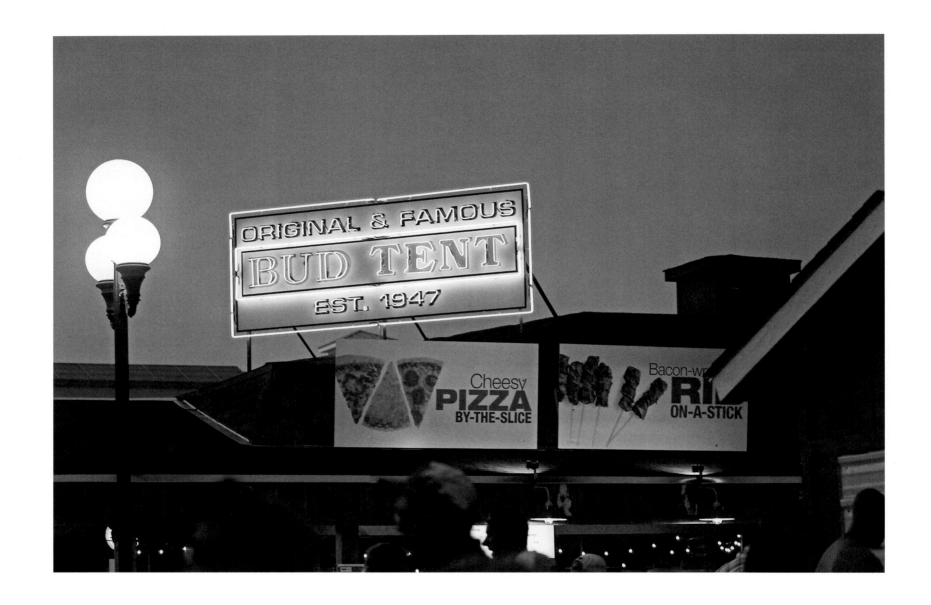

Historic Bud Tent

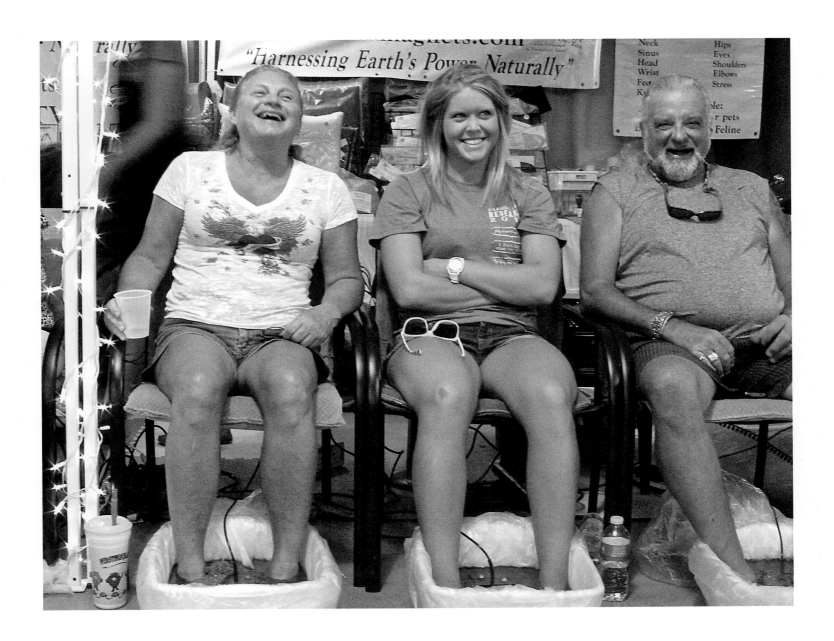

Detox foot-soaking

Vendor selling bubble guns

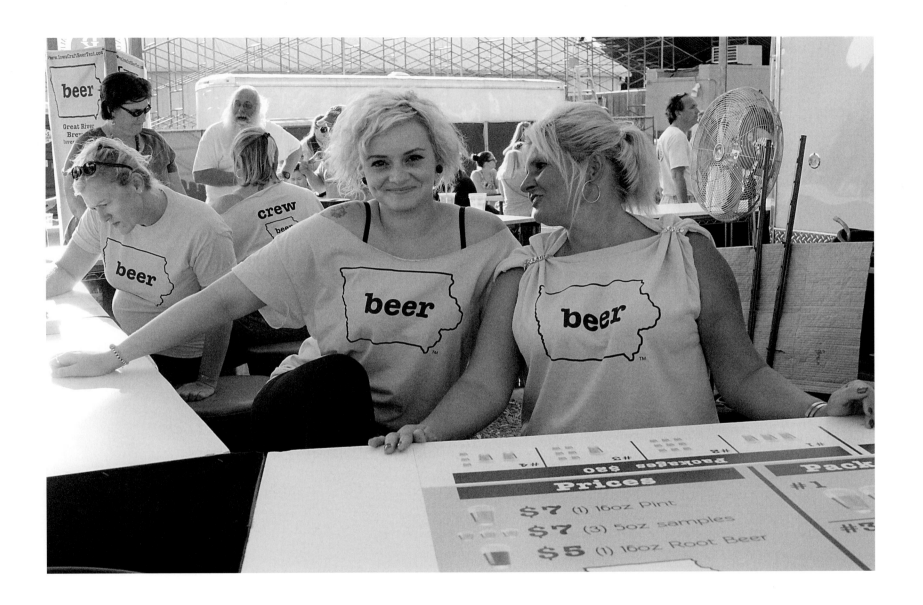

Prices

$7 (1) 16oz Pint
$7 (3) 5oz samples
$5 (1) 16oz Root Beer

Iowa Craft Beer Tent workers

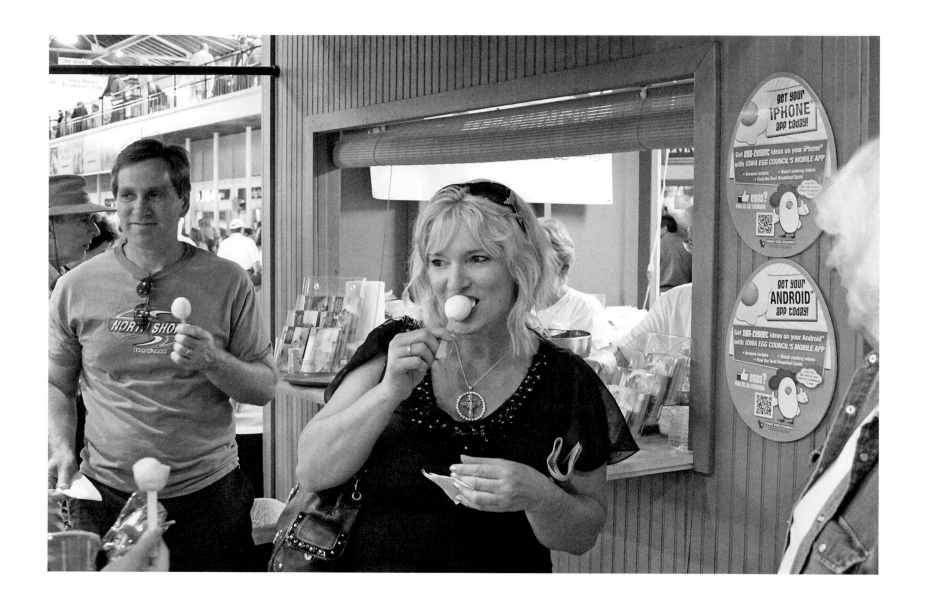

Hardboiled eggs on sticks

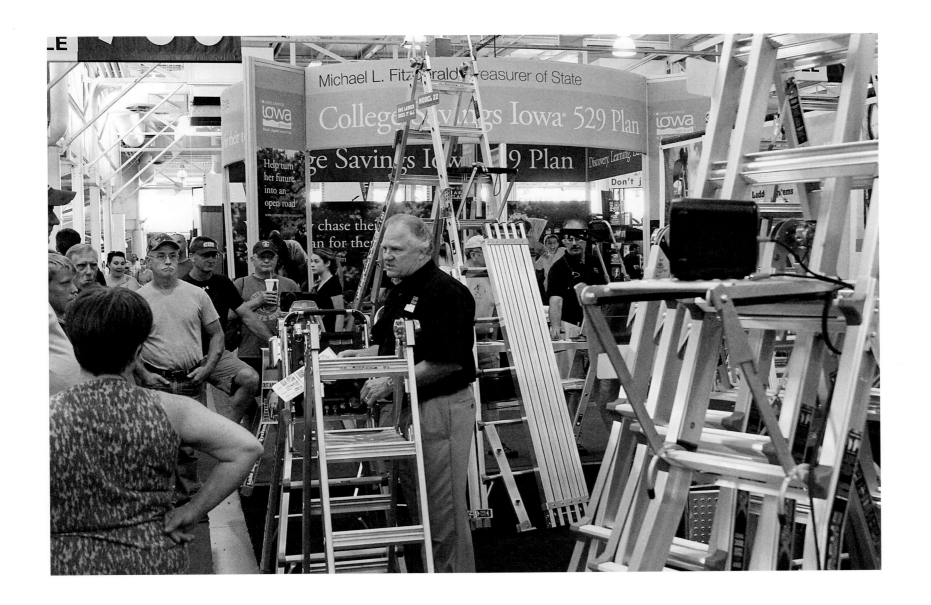

Ladder salesman draws a crowd

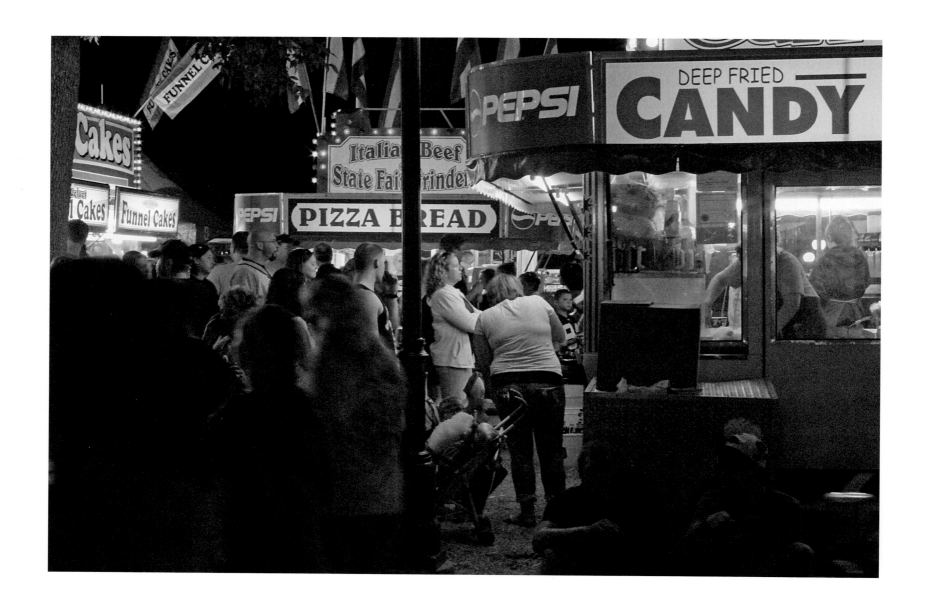

Deep-fried candy

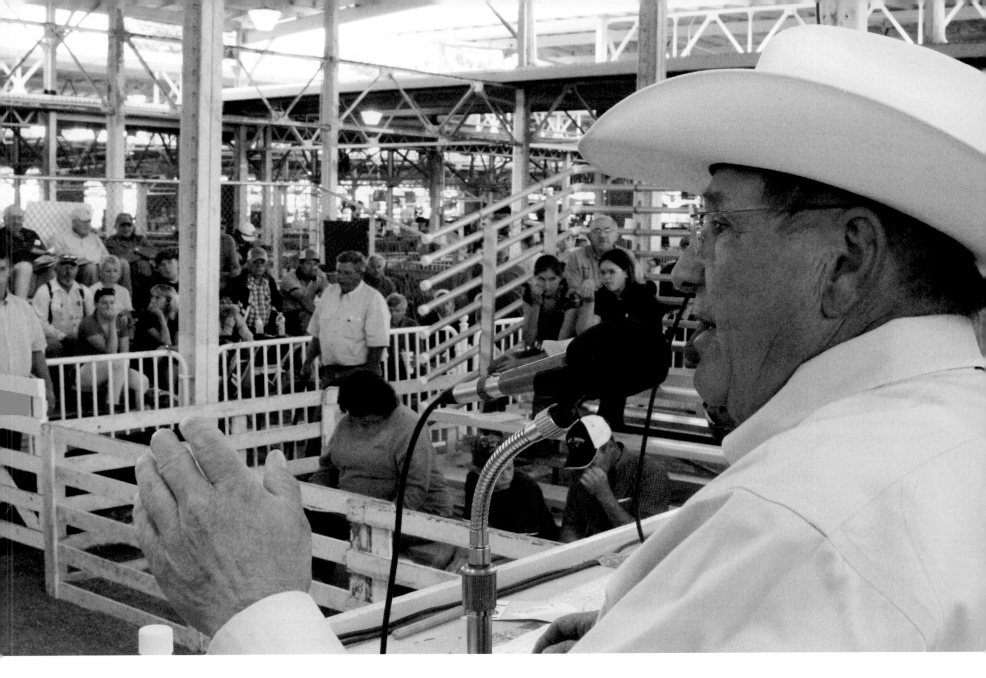

Swine auctioneer

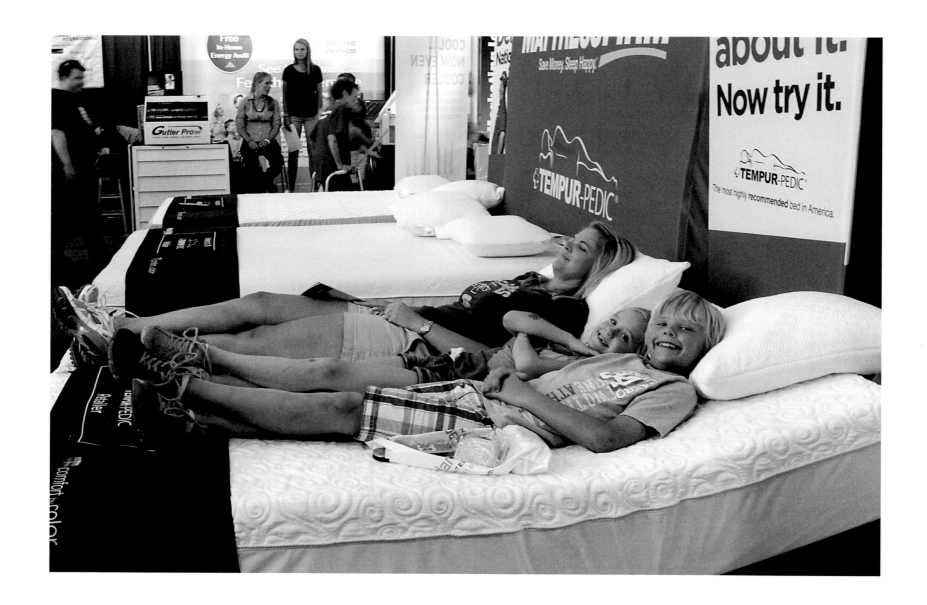

Mom and children mattress testing

Bauder's Ice Cream customer

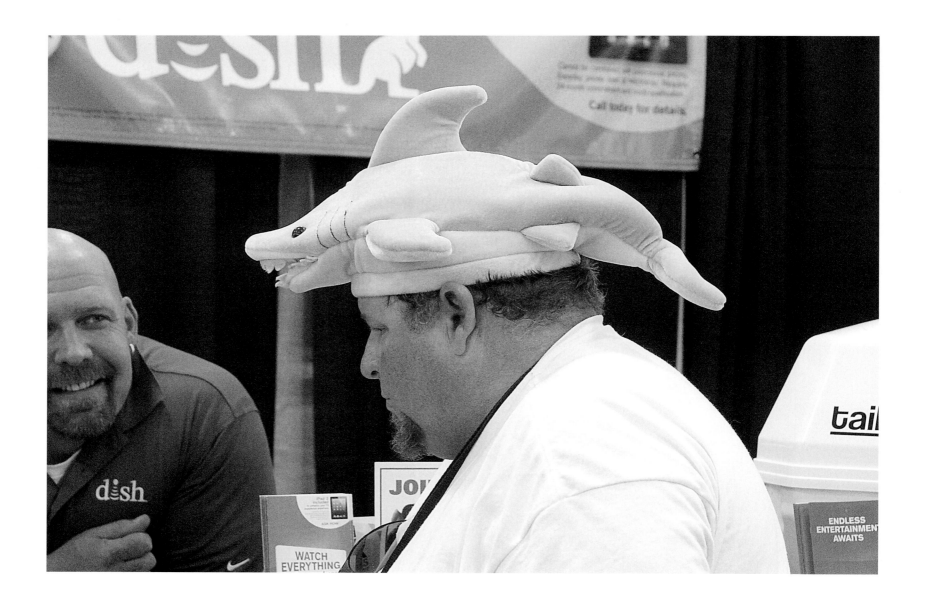

Satellite customer in shark hat

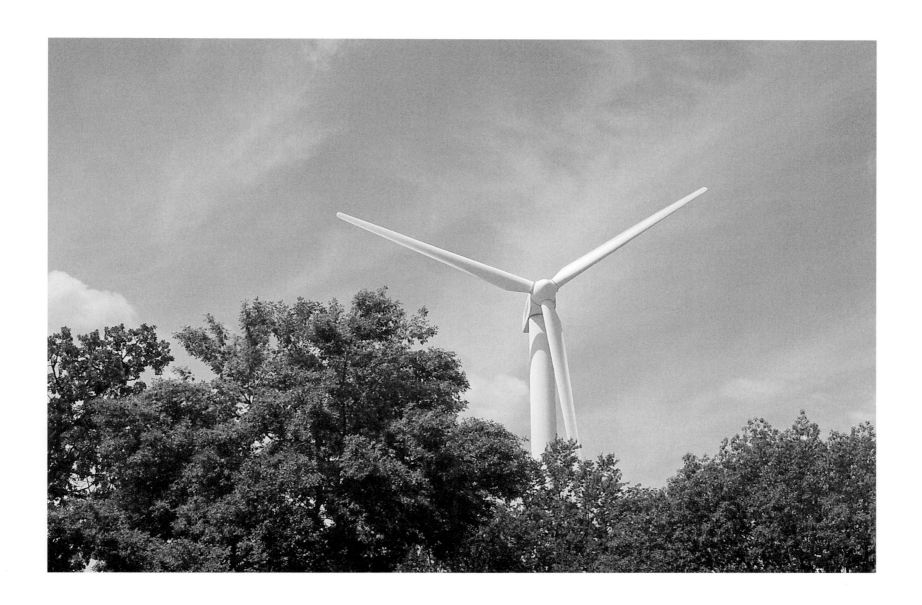

Mid-American Energy's wind turbine

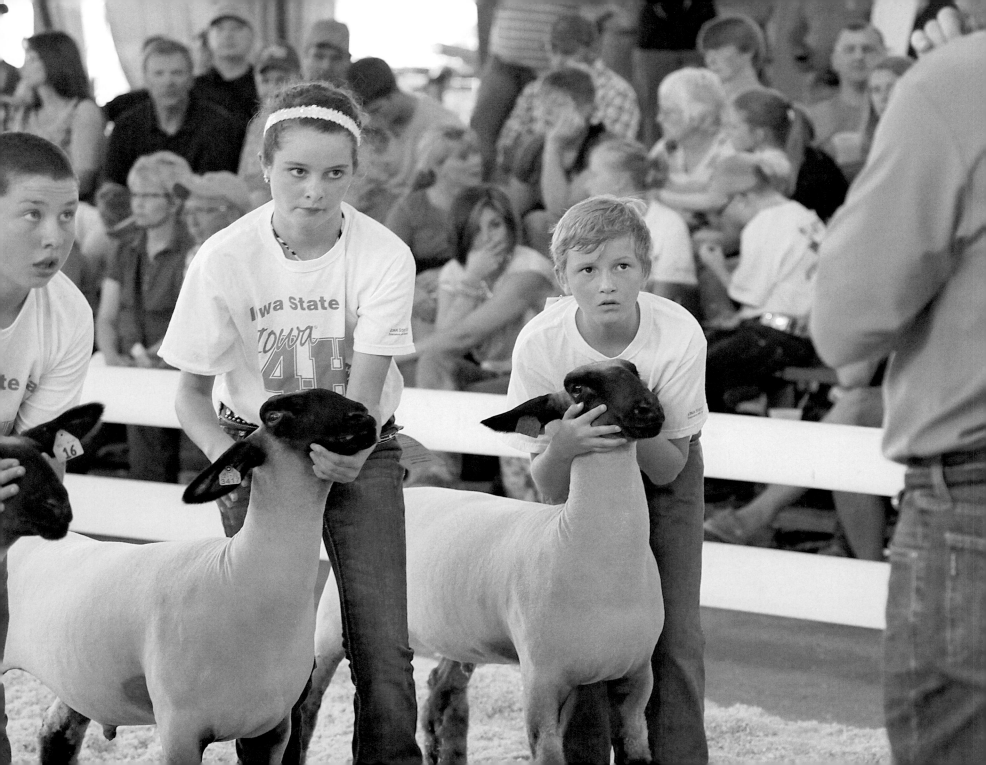

## YOUTH

In the early-morning coolness of the sheep barn, industrial-sized fans push around the air. Earnest young FFA members, all wearing identical, white, tucked-in FFA t-shirts, show their speckle-faced ewe lambs. Most of the young women wear snug blue jeans and eye-catching rhinestone-covered belts. Some take it a step further with rhinestones embroidered on the back pockets of their jeans. For whatever reason, the young men choose not to set themselves apart, content facing the world in brown chore boots, brown belts, and loose-fitting jeans.

Just up the pedestrian way called Rock Island Avenue, fifth- and sixth-grade boys and girls spell words out loud, stumbling on some word like "indiscriminate."

Halfway up in the seats, an older couple sits transfixed, half smiling, mouthing each letter along with the contestants, as if by sheer willpower they can help the young spellers succeed. For a few moments, it feels as if this might actually be heaven on earth, sitting in an air-conditioned barn arena on a hot Iowa day, thinking about words, sure that Iowa's future is in good hands as each child steps to the microphone.

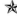

To the north on the Grand Avenue Concourse, very young children compete head-to-head on low-slung plastic tricycles called, generically, 'big wheels.' They pedal feverishly, erratically, not knowing that they pedal before a storm they don't yet see, the storm of adulthood, a storm that will eventually catch up to them and never completely pass over. All they know is that as long as they keep their feet moving, unhappiness fades to black and a ribbon awaits.

On a day set aside to honor veterans of our armed services, achingly young men and women march in a parade alongside veterans from the battles in Vietnam, Cambodia, and Laos. In the elusive quicksilver we call time, the faces blur and the National Guard troops turn out to be young men and women who are students at Iowa State University. The U.S. submarine veterans who pass our spot on the curb of Grand Avenue chant "surface, surface, surface," as if the great arrow of passing years never happened. Young recruits step along smartly, lifting a giant American flag over their heads.

Down at the 4-H Building young people mount a stage to make presentations to appreciative audiences comprising parents, grandparents, siblings, and those who just happen to be passing by. Two girls from Cedar County wearing beards and stovepipe hats tell us about the road known as Lincoln Highway, the one that passes through Iowa on its winding way west, and they do so with graphics, choreography, a bit of singing, unison chanting, and charm, pure charm.

During one of the first days, dozens and dozens of young women begin preparing their horses and themselves for the Cowgirl Queen Contest at the Richard O. Jacobson Exhibition Center and it's a surprisingly beautiful thing. The horses are gorgeous and exceedingly well-trained. For the couple of hours when they ride, the young women are no longer kids from Norwalk, Waverly, or Mason City. They have become Bruce Springsteen's "Sandy," dressed like stars. They are queens, royalty on horseback, and the rest of us feel positively plain and uninteresting.

This is as it should be, as any good fair is ultimately about the future of agriculture, and if you're talking future, you're talking youth. Here at the Iowa State Fair young people rule.

Up on the Midway, a wondrous, small child rides a carousel horse, holding fast to the pole, her mother faintly touching her back as her steed gallops up and down, running counterclockwise, starting nowhere and going nowhere.

Nowhere is a great destination, a comfortable tourist town we've all visited. And one day, many years from now, the young carousel rider will walk past the glittery, magical carousel in Leicester Square in the heart of London and she'll laugh and think of outings to the Iowa State Fair with her beautiful mother, the woman who always kept her on her horse. And, if she's very lucky, the person with her will understand.

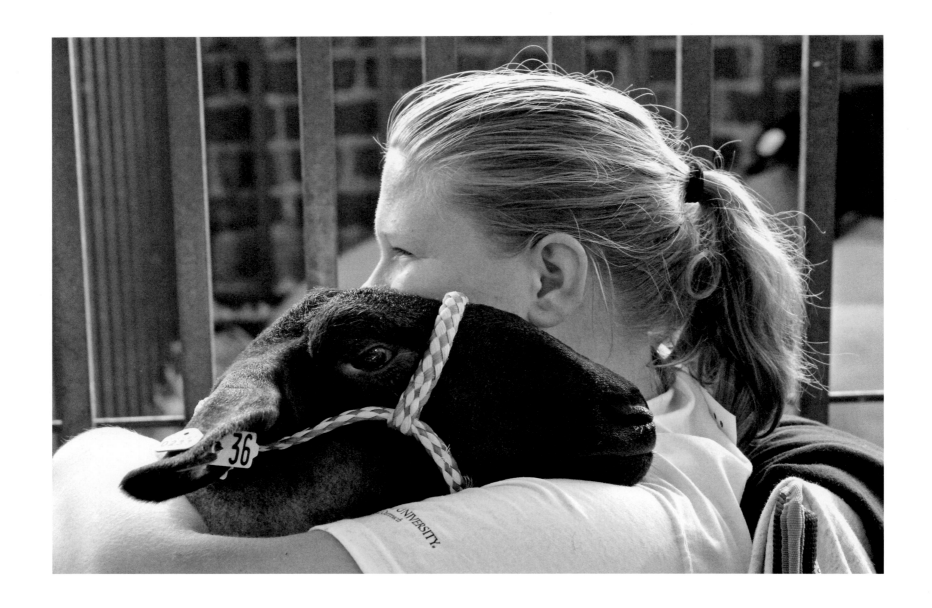

FFA member and her sheep

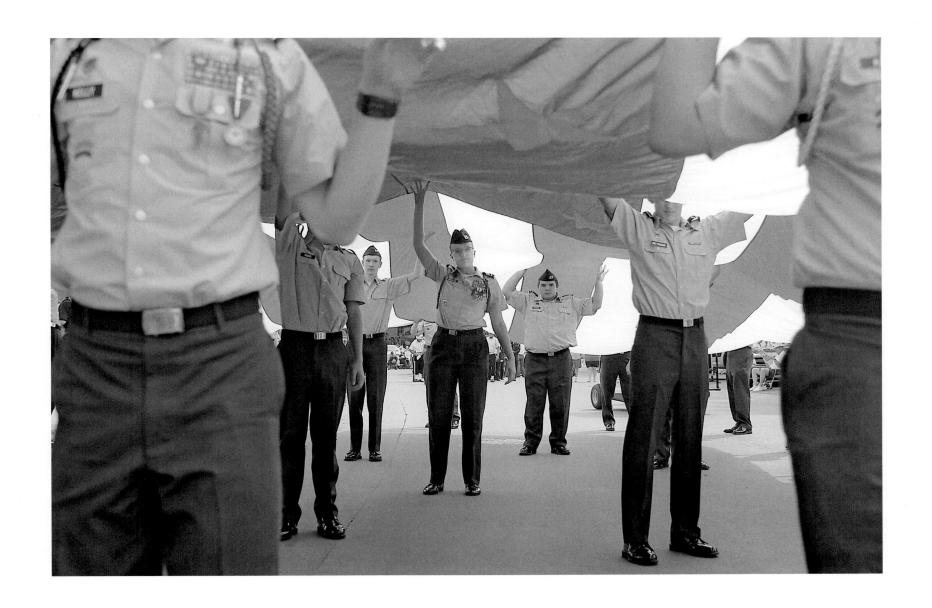

Veterans' Day parade flag raising

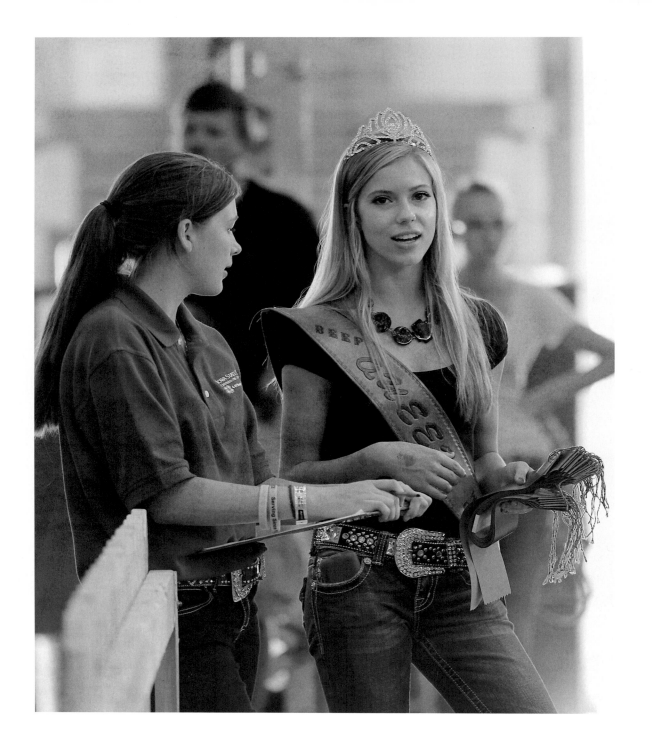

Beef Queen hands out ribbons

Obeying "Pet Me" sign

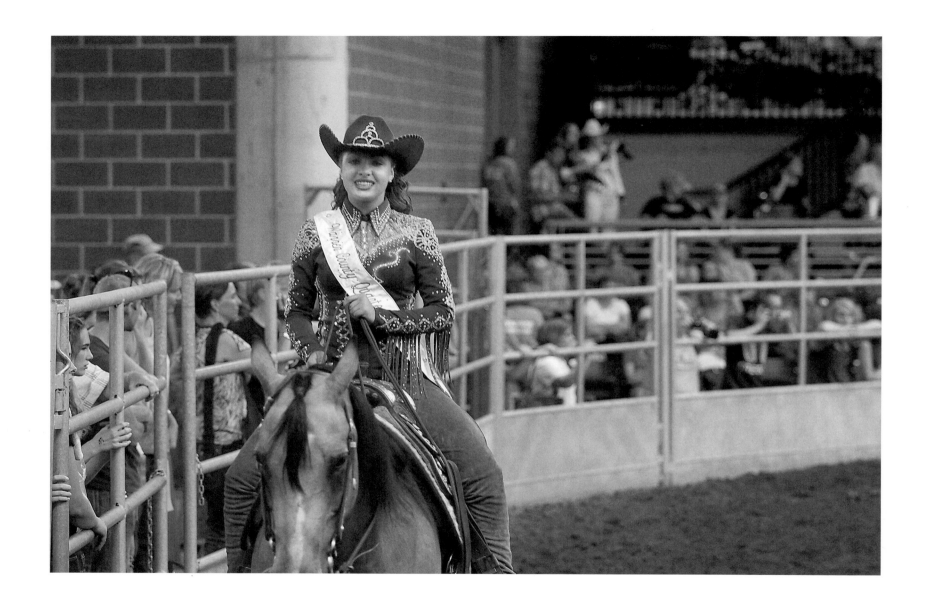

Cowgirl Queen circles the ring

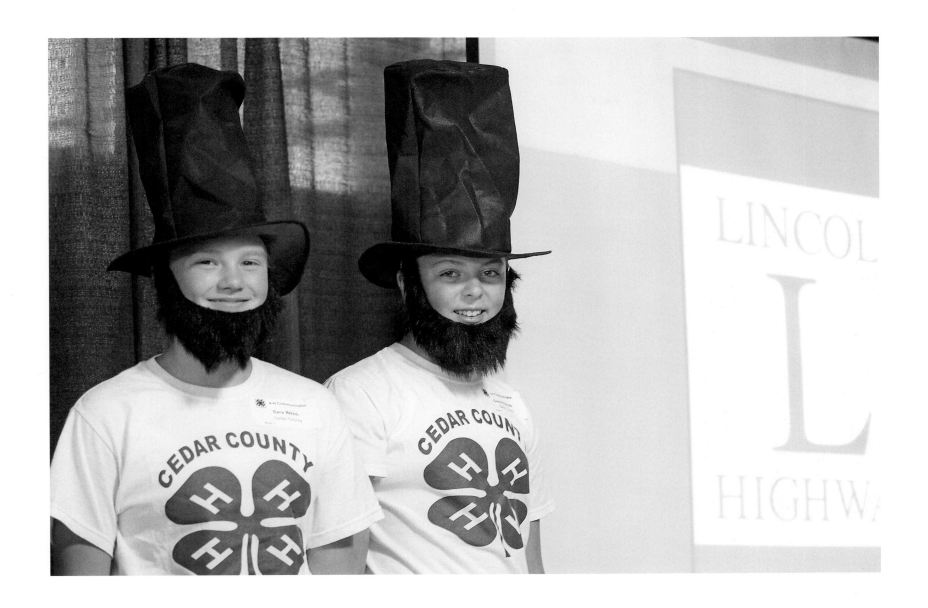

4-H presentation on Lincoln Highway

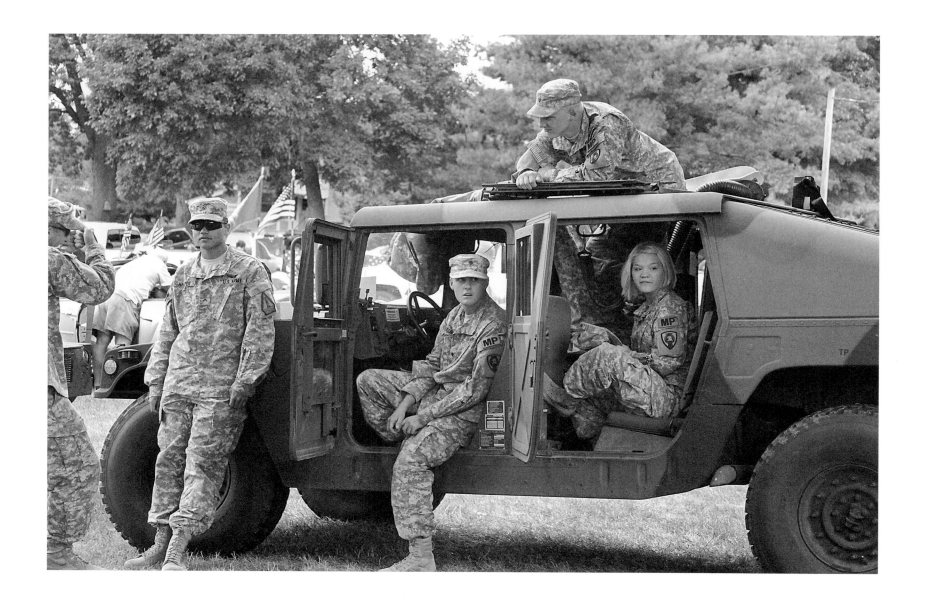

National Guard, awaiting Veterans' Parade

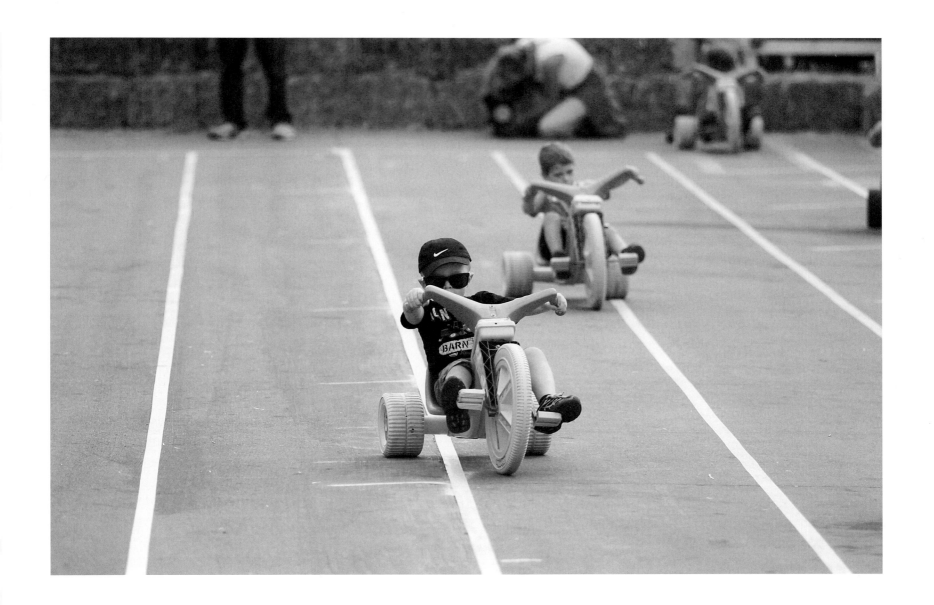

Big Wheel racers

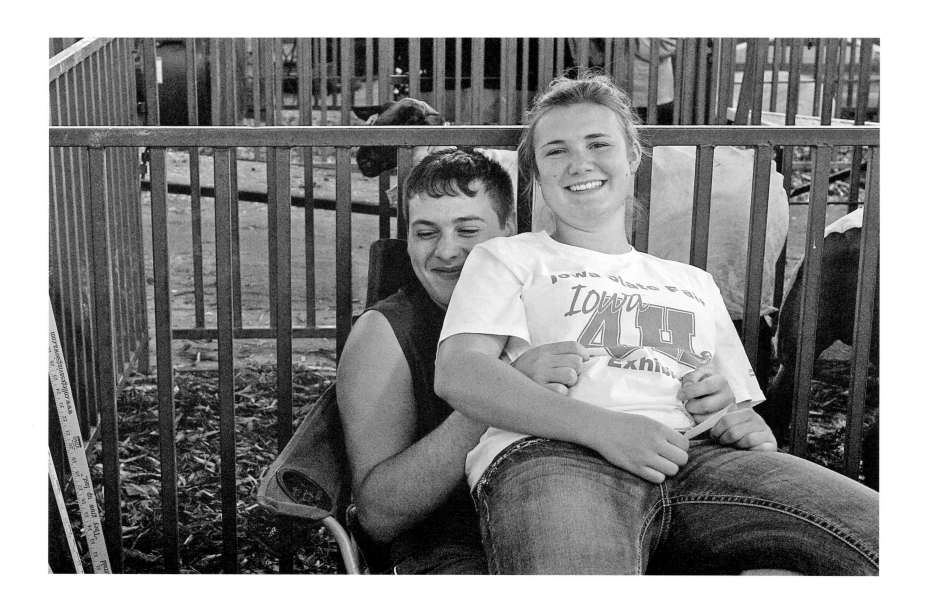

4-H friends share a laugh

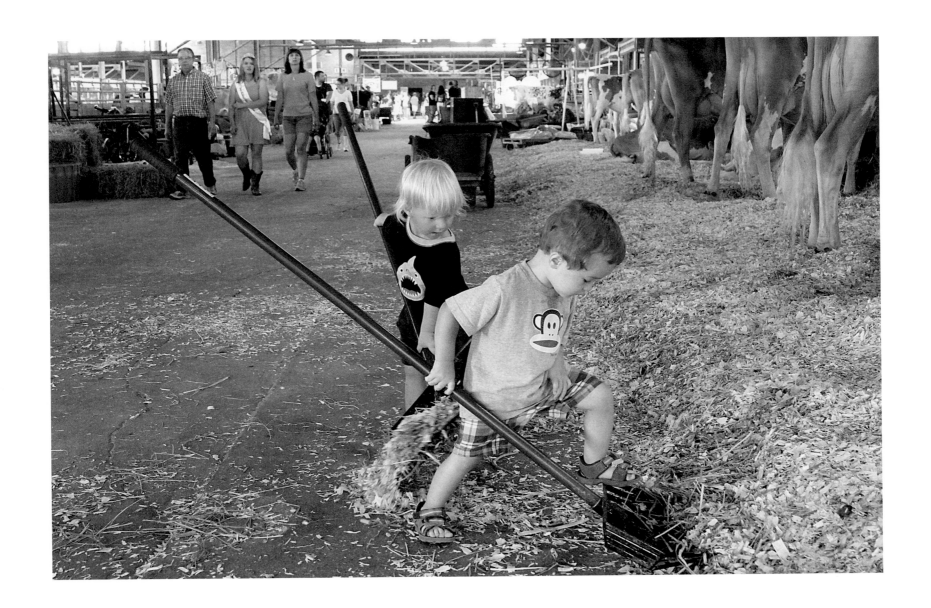

Never too young to farm

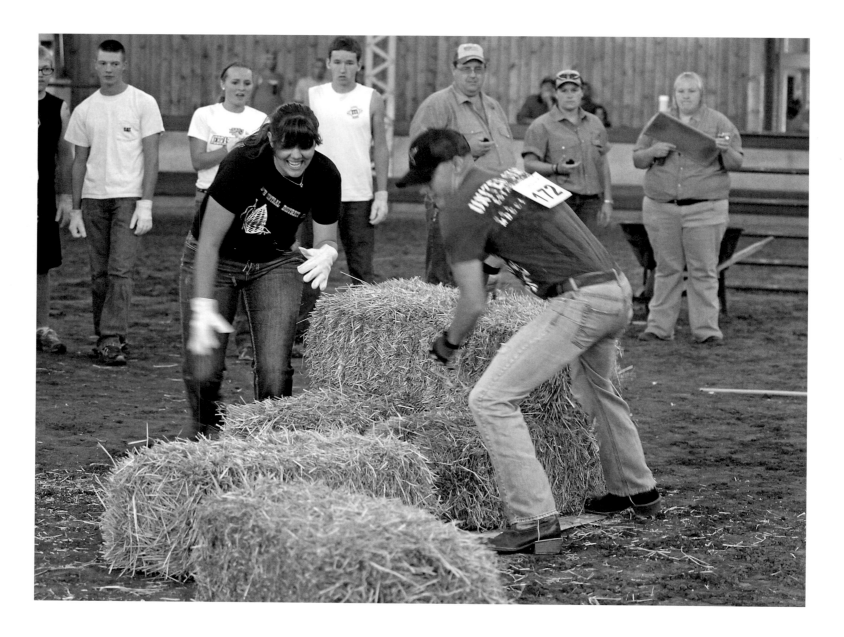

Young Farmer's Challenge: hay stacking

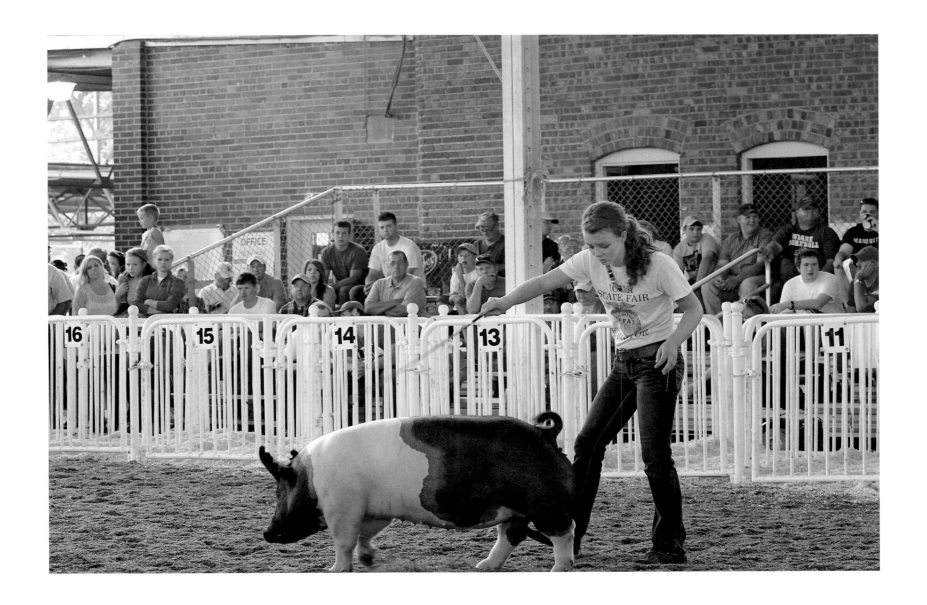

Graceful swine ballet

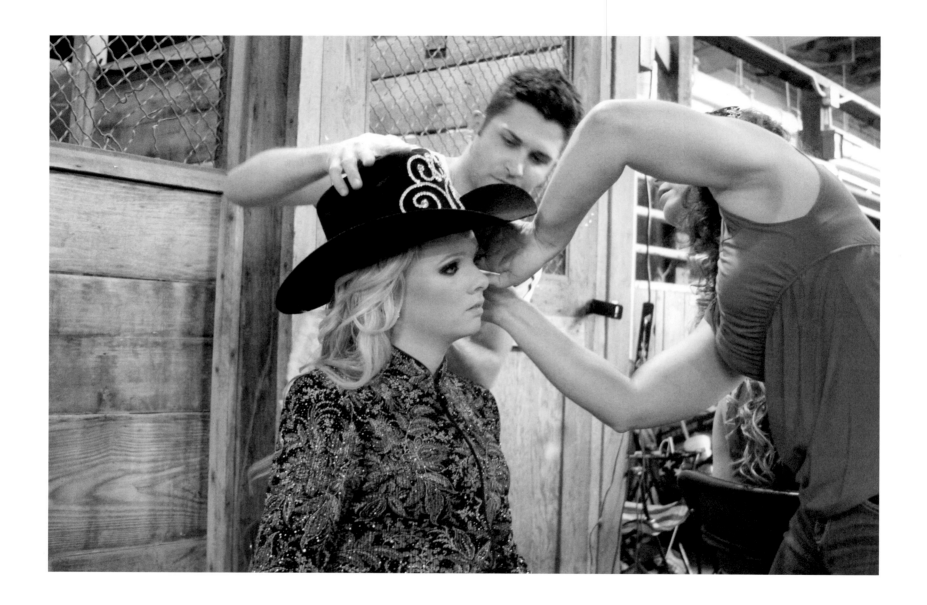

Cowgirl Queen contestant

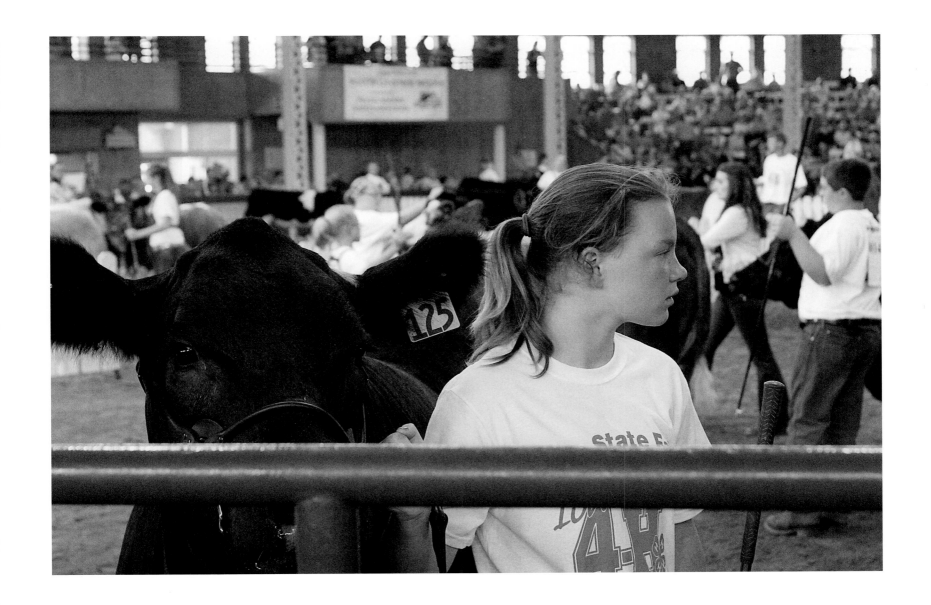

4-H competitor and her steer

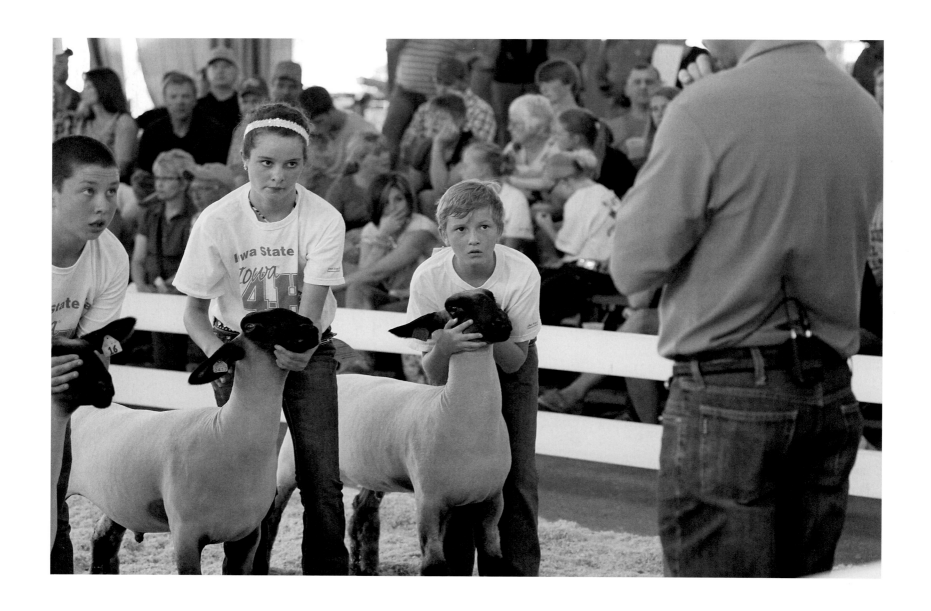

4-H competitors eye judge

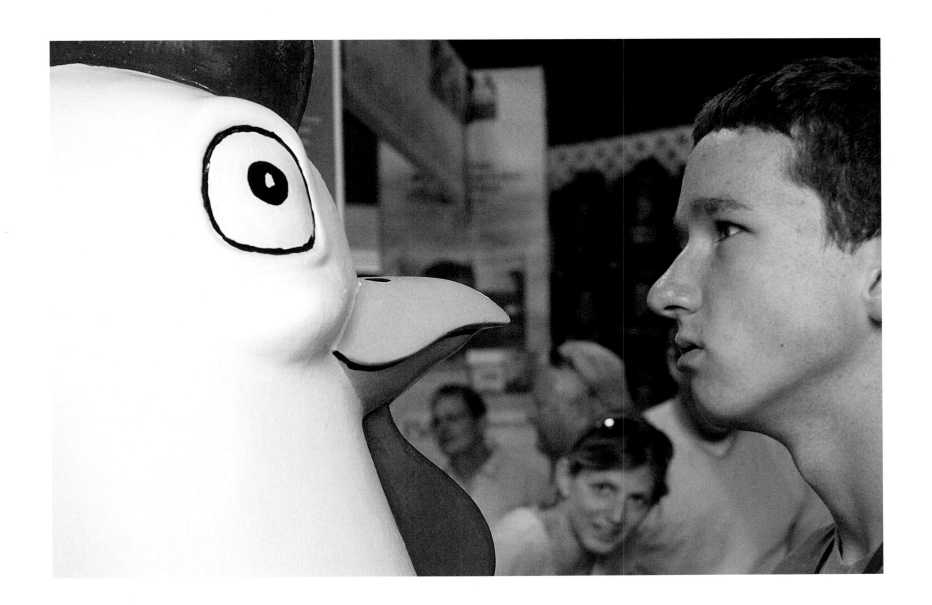

Young man confronts bird

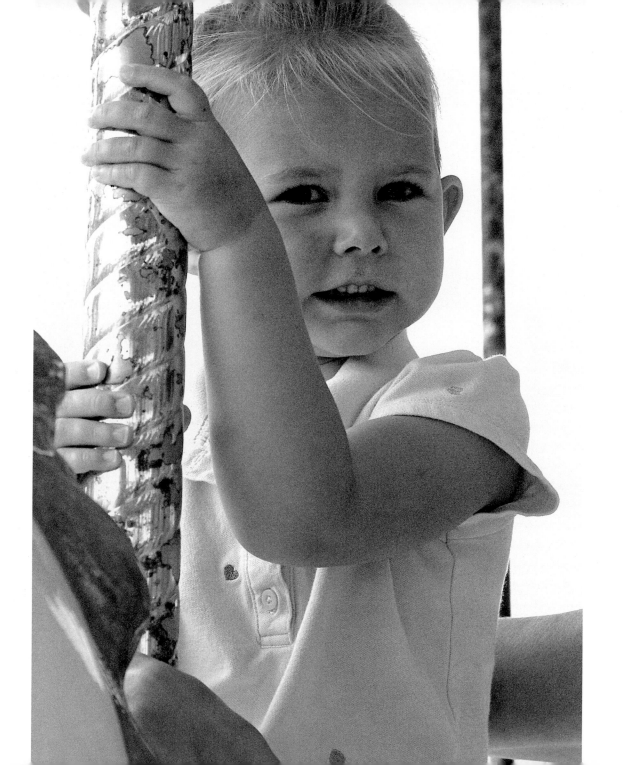

Carousel rider

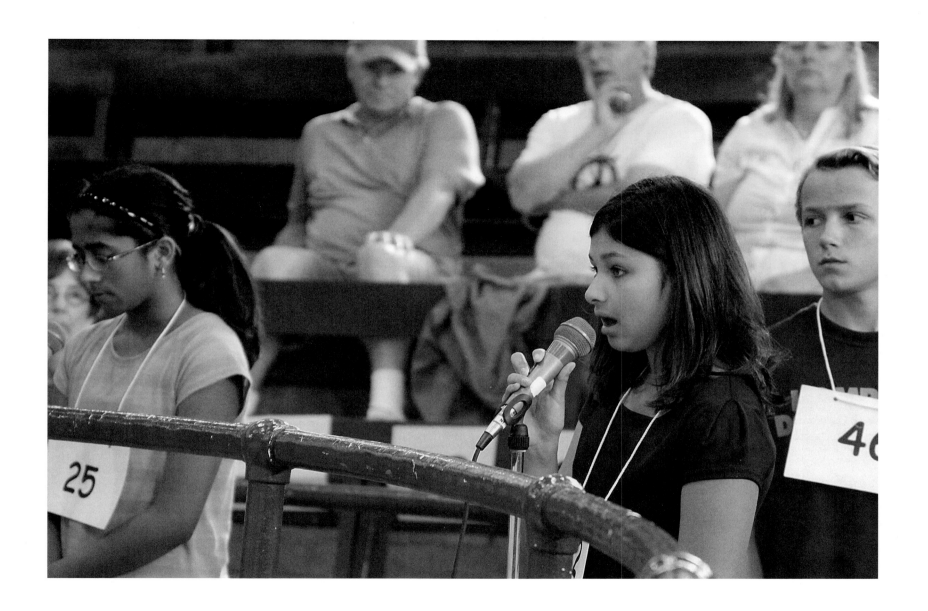

Youth Spelling Bee

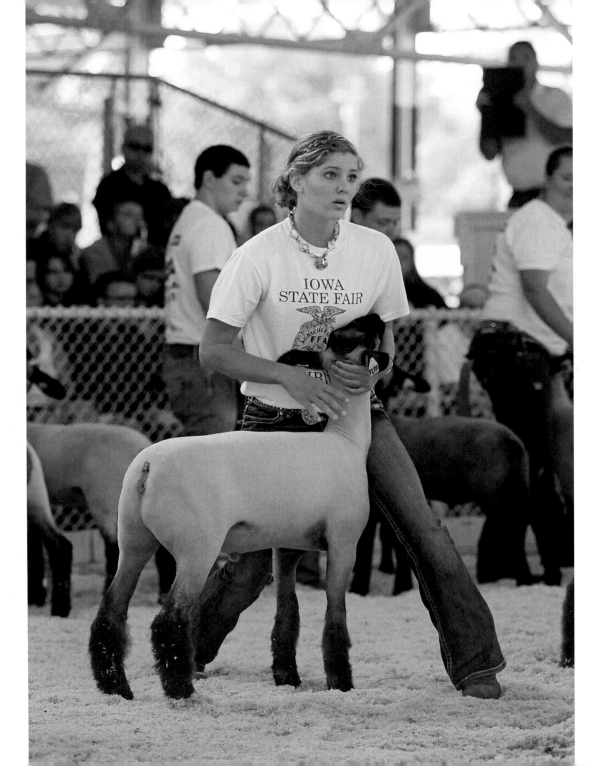

FFA competitor watches judge

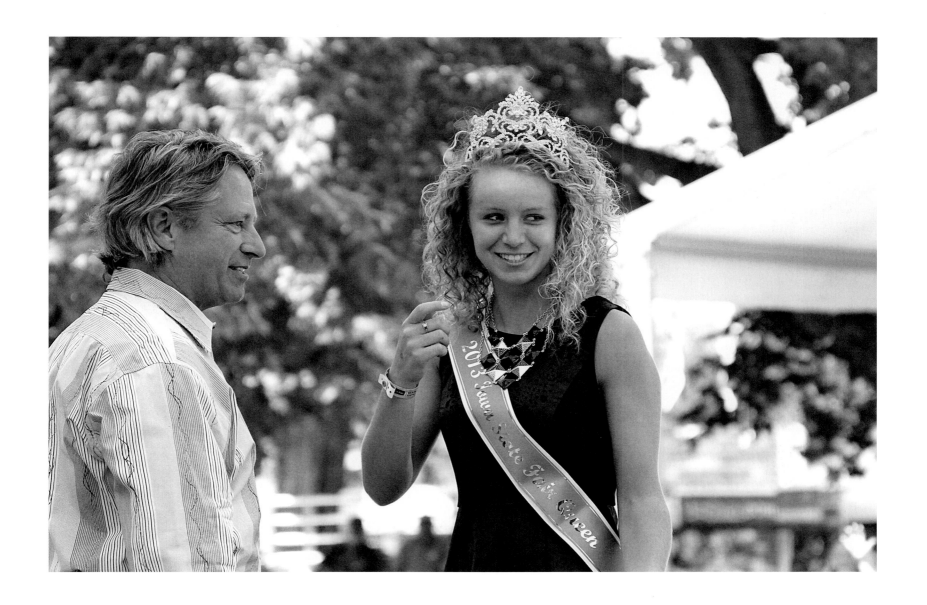

2013 Iowa State Fair Queen

## AFTERWORD

The final night of the fair and the day leading up to it has been great, better than great. Out on the highway just north of town, black-and-rust caterpillars have already begun their annual suicidal crossings. The church service at Pioneer Hall in the morning felt just right, and perhaps you caught the second half of the dog show over at the Pioneer Livestock Pavilion, vowing to spend some serious training time with your own dog. Later, you'll drift along the outskirts of the senior division finals of Bill Riley's Talent Search, standing in the shade at the back next to a small booth where you can purchase a glittery tiara, and you're tempted.

After dusk, everything changes: this night feels different from the others. Most of the young people have been back in school for a few days already, so it's quieter, less hectic, less like the commotion of Times Square, more like the feel of Friday night downtown, circa 1958, when dad wandered the aisles of the hardware store down on Main Street and mom stopped in the one women's store to pick up some thread and look over the paper packages containing the newest dress patterns.

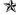

A fishing net of stars has been tossed into the night by an unseen hand. Out on the Midway, lights continue to burn bright, a last gasp before crews dismantle the hydraulic beasts that have lived on the grounds for a week and a half. Lights are dimming in most of the halls as an August moon rises higher and higher above the Big Wheel. You can still hear the squealing of delight from riders on the Tilt-A-Whirl, hanging on, trying not to crush the laughing person next to them. The games carry on. The guy who thinks he has a major league fastball is still sure the radar gun is rigged, paying a few bucks each time while his girlfriend watches, bemused. The carousel is mostly empty. Time is slowing to a crawl and nothing is as it was.

And soon enough all of the temporary lights will go out. Human activity will slow in the wake of tedious cleanup tasks and too little sleep. The big industrial fans in the barns will be shut down and, out in the neighborhoods, children will trundle off to bed, knowing that rising for school the next morning will be difficult. The world of cotton candy and carnival rides is over. Soon enough windows will be closed, lawn mowers put away for the season.

Farm families will sit around a dinner table one last time, to sum up the year at the fair, before the real world once again intervenes, sending some to the barn for cleanup chores and others to feed livestock. There too the lights will go out, with the exception of that yard light mom insisted on a few years back, the one that causes you to pull the blinds before sleep. And sleep comes. It always does. Summer is over and it's time to make a deal with the moon, or whatever lights still shine overhead.

After midnight, the night exhales, and it's over. This prairie Brigadoon that appears out of the mist every August is gone, gone to wherever it is that dreams, love, aspirations, and happiness go. Until next year.

**Iowa and the Midwest Experience**

*On Behalf of the Family Farm: Iowa Farm Women's Activism since 1945*
by Jenny Barker Devine

*What Happens Next? Essays on Matters of Life and Death*
by Douglas Bauer

*A Store Almost in Sight: The Economic Transformation of Missouri from the Louisiana Purchase to the Civil War*
Jeff Bremer

*The Lost Region: Toward a Revival of Midwestern History*
by Jon K. Lauck

*The Drake Relays: America's Athletic Classic*
David Peterson

*Iowa Past to Present: The People and the Prairie, Revised Third Edition*
by Dorothy Schwieder, Thomas Morain, and Lynn Nielsen

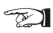